CONTEMPORARY ART

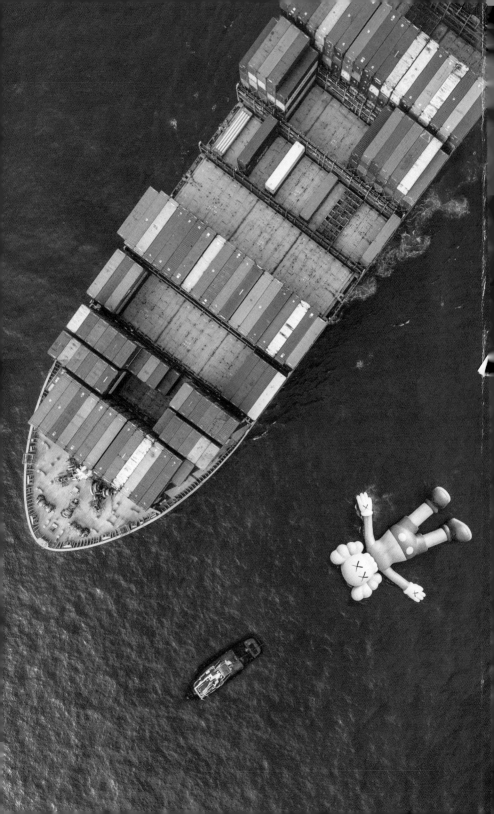

ART ESSENTIALS

CONTEMPORARY ART

—

NATALIE
RUDD

—

CONTENTS

INTRODUCTION

Have you ever stepped into a contemporary art gallery and felt the urge to walk right out again? Have you encountered a piece of contemporary art and wondered what it was about? Do you find yourself befuddled after reading the 'explanatory' labels in galleries? Would you like to feel more comfortable around contemporary art? If you answered 'yes' to any of these questions, then this book is for you.

This book provides a plain-speaking, jargon-free account of contemporary art. It invites you on a journey through some of the major developments and breakthroughs. Each chapter begins with a frequently asked question about contemporary art. The subsequent discussion offers themes, ideas and suggestions to enable you to draw your own conclusions. The spotlight sections offer specific insights into the work of thirty diverse artists. The themes and groupings expressed in this book are deliberately fluid

and open. They are intended to offer a starting point for thinking, rather than to fix or limit this rich domain. Many of the artists could have been discussed in more than one chapter, and there are, of course, more artists and approaches out there to be discovered. Each chapter ends with prompts for further enquiry.

At the back of this book, you will find a 'toolkit'. Featuring key dates, suggested ways of looking and links to additional resources, the 'toolkit' provides everything you need to continue your investigations into contemporary art.

The very best way to approach contemporary art is with an open mind and an inquisitive spirit. Give yourself time to look and think, ask questions, take a view, get involved. But most of all, have fun.

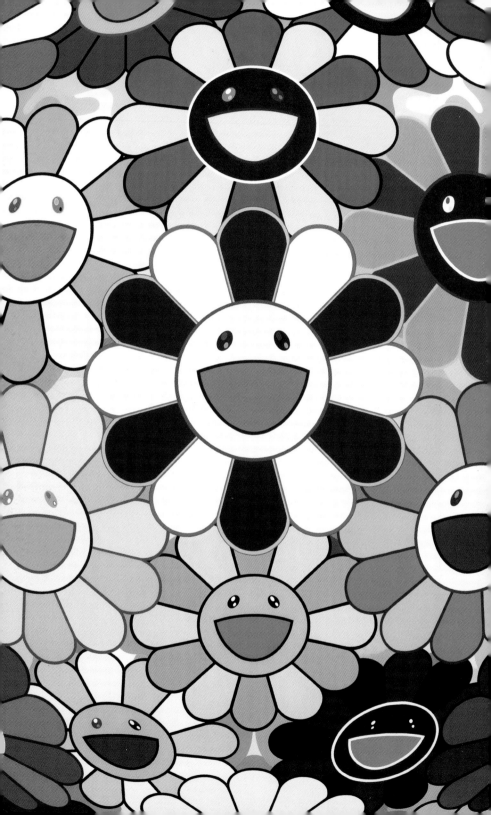

HOW DID WE GET HERE?

-

We want to see the newest things. That is
because we want to see the future, even if only
momentarily. It is the moment in which, even if
we don't completely understand what we have
glimpsed, we are nonetheless touched by it.
This is what we have come to call art

-

Takashi Murakami, 2018

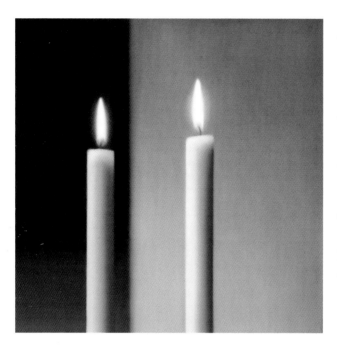

Gerhard Richter
Zwei Kerzen (Two Candles),
1982
Oil on canvas
140 x 140 cm
(55⅛ x 55⅛ in.)

Richter is considered
to be a Conceptual
painter. He shifts
between abstraction and
realism to comment on
the nature of painting
itself. In 1982–3,
Richter worked from
photographs to develop
a series of paintings of
lit candles. These works
recall vanitas still-life
paintings and explore
ideas of uniqueness and
reproduction.

Contemporary art can be found in every corner of the globe and
in countless different settings. You can discover it in public and
commercial galleries, in art fairs, auction houses and biennials.
You might stumble across it in a public park or plaza, download it
on a digital platform or engage with it through artist-led initiatives
or open studios.

**Contemporary art has yet to be pushed through the
sieve of art history**

Rising stars may yet fall. The artist working in your neighbourhood
might still rise to the top. This is exciting, speculative terrain.
Everything is still to be played for.

When listening to people talking about contemporary art
it is common to hear exclamations such as 'I just don't get it,' or
'It all looks rubbish to me!' Art occupies our culture, like music,
consumer goods and fashion. We feel that we should be able to
grasp it. But to many people, contemporary art feels inaccessible.
The easiest solution in the face of such difficulty is to abandon
all hope of comprehension. Such sentiments are understandable;

it can seem difficult to know where to start. As with any area
of knowledge, it is important to recognize that the world of
contemporary art has its own histories, specialist terms and
reference points. The more you discover, the more understandable
contemporary art will become.

WHAT IS CONTEMPORARY ART?

Rasheed Araeen
Rainbow, 2015
Acrylic and wood
30.5 x 30.5 x 30.5 cm
(12⅛ x 12⅛ x 12⅛ in.)
British Council Collection

**Araeen is a London-based
Pakistani artist, curator
and writer. Through a
range of exhibitions
and publications, he has
campaigned tirelessly
to combat racism in
the art world. *Rainbow*
reflects Araeen's interest
in breaking down the
rigid structures of
Minimalism. Visitors are
invited to interact with
the cubes to create new
configurations.**

To get started, let's draw a line in the sand and state that
contemporary art is the art of our time. But what is 'art' and how
do we define 'our time'? There are many theories about what art is
and what art should contribute to society. We will encounter some
of these ideas as this book unfolds. However, in a nutshell, it can be
helpful to think about art as a diverse set of creative practices that
prompt reflection on the world around us. Artists today employ
a seemingly limitless range of materials and processes. Yet, when you
dig beneath the surface of these different means of production and
consider the essence of art, you could say that art is fundamentally
philosophical in nature. Art is a place where ideas can be shaped
and shared.

The question of what 'contemporary' means is also a source of
speculation. When did contemporary art start? Did it start ten,
twenty-five, perhaps fifty years ago? Given this is an introductory
guide, we need to set some limits to keep us on track. So, this book
will explore art made during the last twenty-five years: loosely, from

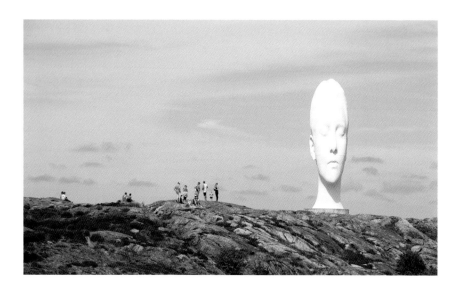

the final years of the last millennium up to the time of writing. We will, however, keep dipping our toes into the past, to trace where an idea has come from or to acknowledge a particular influence. After all, every period throughout history has witnessed the production of its own contemporary art, and artists have always looked backwards as well as forwards.

POST-WHAT?

Contemporary art didn't just appear out of nowhere. It emerged gradually, through a complex process of experimentation and debate. Some critics believe that the roots of contemporary art as we know it today took hold in the late 1960s when artists began to question the dominant narratives of Modernism.

Since the late nineteenth century, generations of artists have taken successive steps away from simply representing the world to pursue new realities. This Modernist process of reduction and refinement ultimately led to the Minimalist sculpture and painting of the 1960s. By the end of the decade, many artists were beginning to find this approach limiting.

Jaume Plensa
Anna, 2015
Polyester resin and
marble dust
14 x 4.3 x 5.7 m
(45 ft 11¼ in. x 14 ft 1⅜ in.
x 18 ft 8½ in.)
Pilane Heritage Museum,
Klövedal, Sweden

Based in Barcelona, Plensa harnesses a range of materials and technologies to create large-scale figurative sculptures for public spaces all over the world. With their eyes closed gently in quiet reflection, these massive, meditative beings invite us to reflect on issues of inside and outside, public and private, earth and sky.

-

They tore up the rule book and introduced a whole range of methods and ideas, deliberately making things messy

-

Senga Nengudi
Performance Piece, 1978
Nylon mesh
Senga Nengudi and
Maren Hassinger at
Pearl C. Woods Gallery,
Los Angeles, 1978

Nengudi played an important role in the black art scenes of New York and Los Angeles during the 1960s and 1970s. Her radical performances of the 1970s involved interactions with a range of found materials such as stretched tights, to reflect upon the societal restrictions imposed on women.

Some artists, including Senga Nengudi and Yayoi Kusama, used their own bodies and experiences to forge radical performances and installations, often harnessing soft, malleable materials. Other artists embarked on a conceptual approach, which, in its extreme form, involved the wholesale rejection of unique art objects in favour of pure ideas. Any material, any action, any encounter, could be art if the artist deemed it so.

Artists wanted their work to be relevant to wider society. They sought greater interaction with the outside world, presenting or enacting their work in urban or rural spaces. Art dealing with social and political issues, including feminism, racial equality and LGBTQIA+ rights, increased. Campaigns for better representation within art and society gained momentum across the 1970s, with marginalized artists working individually and collectively across the decade to drive change. Overall, art had entered its 'Postmodern' phase: *out* with streamlining, *in* with unbounded possibility. This state of restless activism and experimentation has proved to be incredibly resilient.

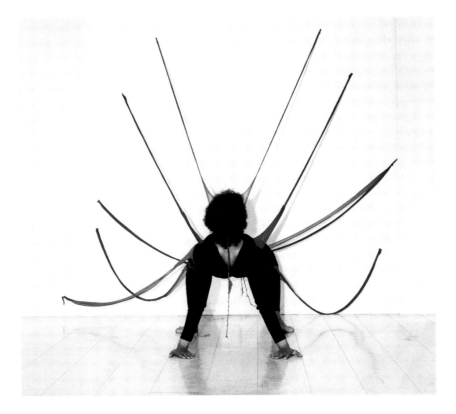

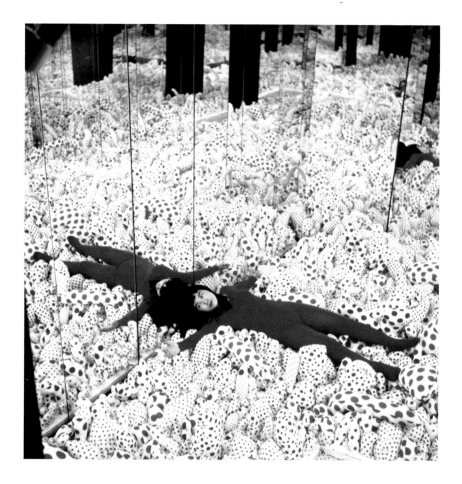

Yayoi Kusama
*Kusama in Infinity Mirror
Room – Phalli's Field*, 1965
Castellane Gallery,
New York, 1965

Japanese artist Kusama
has experienced
hallucinatory visual
disturbances since
childhood. Much of her
art attempts to make
sense of her condition:
polka dots cover many of
her works, from naked
performers to bulbous
hand-stitched phallic
forms. This work was one
of Kusama's first 'Infinity
Mirror Rooms', in which
she used mirrors to create
an illusion of infinite
space.

Georg Baselitz
Adieu, 1982
Oil paint on canvas
2.5 x 3 m (8 ft 2½ in. x
9 ft 10⅜ in.)
Tate Gallery, London

Neo-Expressionist
painting became
popular in the 1980s.
A generation of German
painters achieved
recognition for large-
scale, gestural work
that reflected personal
and collective histories.
The figures in Baselitz's
paintings are often upside
down, prompting the
viewer to look beyond
the figure and towards
formal concerns.

MAKE IT BIG

The 1980s marked an important milestone in the development of
the contemporary art scene. This commercially driven decade is
credited with establishing the infrastructure for a successful art
market. Certainly, the start of the decade looked unpromising for
art dealers, what with so many artists still intent on developing work
that deliberately avoided actual objects, but a surprisingly swift
return to large-scale, expressive painting and object-based sculpture
boosted the market. Photography also emerged as an important
medium in its own right, with artists such as Andreas Gursky, Cindy
Sherman and Jeff Wall forging influential new directions.

Some of the most commercially successful artwork of the 1980s
blended an insistent return to the art object with a knowing, playful
spirit. Employing a range of specialists to fabricate his works, the
American artist Jeff Koons has developed ambitious, technology-
demanding sculptures and large-scale paintings, a bit like his Pop
Art predecessor Andy Warhol, whose shrewd management of his
studio, which he called 'The Factory', led to massive productivity.
The comparisons do not stop there, for Koons, just like Warhol,
achieved global recognition for his appropriation of existing imagery
and consumer goods. From Michael Jackson and his pet chimp,
Bubbles, to balloon dogs and vacuum cleaners, Koons reinterpreted
his source material using high-gloss surfaces and a super-slick finish.
This formula has proved to be hugely lucrative.

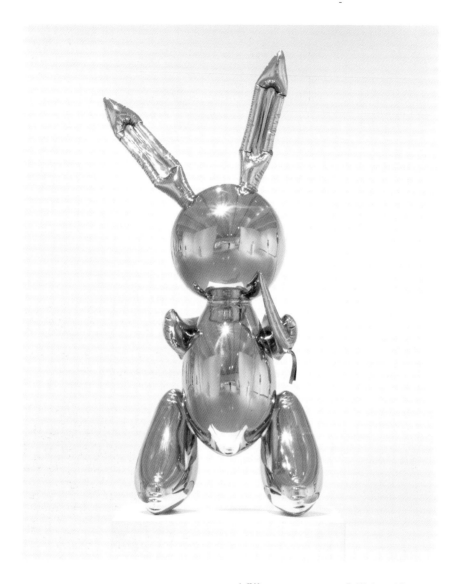

Jeff Koons
Rabbit, 1986
Mirror-polished stainless
steel with transparent
colour coating
3.1 x 3.6 x 1.1 m (10 ft 1 in.
x 11 ft 11 in. x 3 ft 7⅜ in.)

Rabbit **is a stainless-
steel sculpture based
on a child's inflatable
toy. Holding a carrot
and with one ear askew,
the rabbit bears all the
seams and creases of its
original squidgy form.
It stands expressionless,
impenetrable and
predatory.**

In May 2019, Jeff Koons's stainless-steel rendition of an inflatable rabbit sold at auction for a staggering $91.1 million, breaking the record for the highest price paid for an artwork by a living artist

Concerns regarding representation and equality within the art world continued to build across the 1980s. Artists from ethnically diverse backgrounds initiated collective approaches to tackle the institutional lack of attention given to their work. In 1989, for example, the artist Rasheed Araeen curated a major exhibition, 'The Other Story', at the Hayward Gallery, London, which provided an alternative, racially inclusive narrative of modern art. Art by LGBTQIA+ artists including Robert Mapplethorpe and David Wojnarowicz resonated with great poignancy across a decade that witnessed the devastating impact of AIDS. However, their work was met with considerable resistance from conservative audiences in the USA. A major retrospective exhibition of Mapplethorpe's photography at the Institute of Contemporary Art, Philadelphia, in 1988, sparked a ferocious debate around obscenity laws and the use of public funding for the arts.

For much of the 1980s, the art world centred its focus on artists based in the USA or Western Europe. The end of the decade,

David Wojnarowicz
Untitled (Face in Dirt),
1991/2018
Gelatin silver print
31.5 x 32.4 cm
(12½ x 12⅞ in.)

Wojnarowicz was an influential American artist and AIDS activist working across media and disciplines. This work was made collaboratively with his friend, the photographer and filmmaker Marion Scemama, not long before Wojnarowicz died from AIDS at the age of 37. This poignant image sees the artist on the cusp of being consumed by the earth.

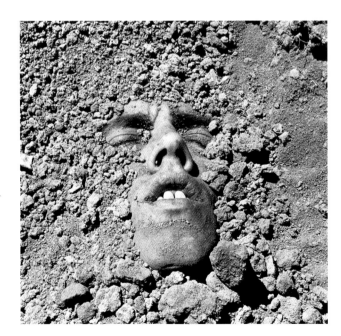

however, saw the first seeds of change. With the dismantling of the Berlin Wall in 1989 and the end of the Cold War just around the corner, there were clear opportunities for the art world to globalize and to develop more inclusive practices.

MAKE IT BIGGER

Rapid advancements in communication rendered the art world an increasingly small place during the 1990s. Cheap flights and the development of the internet led to the creation of a tight global community. The infrastructure for contemporary art continued to grow rapidly, with the launch of many new commercial galleries and major public venues. Guggenheim Museum Bilbao, Frank Gehry's futuristic architectural masterpiece, opened in 1997. At the end of the decade, the art world anticipated the opening of Tate Modern (2000), Herzog & de Meuron's impressive renovation of Bankside Power Station in London.

What better way to enjoy these awesome architectural feats than with a presentation of equally jaw-dropping art? The 1990s witnessed the rise of vast and complex art installations designed to be experienced and interacted with. This spectacular and often participatory art is not easily replicated in books: you simply *have to be there*!

Frank Gehry
Guggenheim Museum
Bilbao, 1997, featuring
Louise Bourgeois, *Maman*,
2001
Bronze, marble and
stainless steel
9.3 x 8.9 x 10.2 m
(30 ft 5 in. x 29 ft 2⅞ in.
x 33 ft 6⅞ in.)

**With 24,000 square
metres of space, the
Guggenheim Museum
Bilbao is one of the
largest public galleries
in Spain. The gallery
programmes temporary
exhibitions and displays
from the Guggenheim's
own collection, which
includes *Maman* (2001),
a massive bronze, marble
and stainless-steel
spider by the French
American sculptor Louise
Bourgeois.**

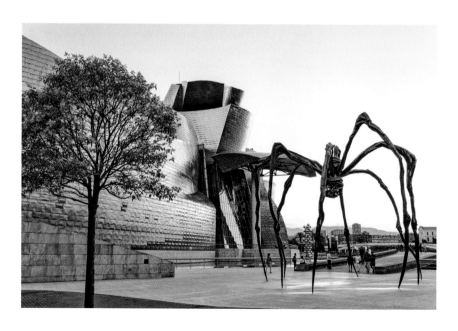

Vanessa Beecroft
VB35, 1998
Performance
Solomon R. Guggenheim
Museum, New York

Beecroft rose to
fame in the 1990s
for confrontational
performances featuring
young women in a
state of undress. Her
work explores issues of
voyeurism and control.
VB35 featured twenty
women who stood for
two hours in a circular
formation to mirror
the Guggenheim's
architecture.

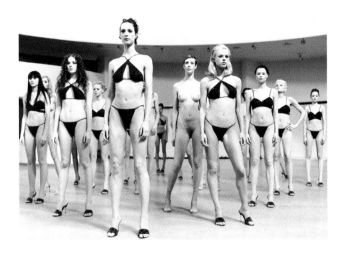

The 1990s also witnessed the rise of the curator. Some prominent figures, such as Hans Ulrich Obrist and Okwui Enwezor, began to enjoy celebrity 'über curator' status. It is now increasingly tricky to pinpoint the initiator of the content: is it the artist or the curator? Most often a successful project emerges from a solid partnership between the two.

ON THE ART TRAIL

Given that the richest 1% of the world's population now owns 43% of the world's wealth, it is no surprise to learn that the art market remains buoyant. Art tourism remains a key feature of the global scene, with an exciting programme of exhibitions and art fairs promising the best new art. Artworks are shipped around the world to meet the demands of these fleeting events. The 'art set' obligingly follows in perpetual search of the next hot thing. Visiting an art fair is a great way to see a wide range of recent art before most of it disappears into private collections. However, when standing in a tent crammed full of very expensive artworks and people dripping in wealth, it is hard not to dwell on inequalities. It is also difficult to ignore the environmental impact of this relentless cycle of display.

Another significant fixture in the art-lover's diary is the biennial, a major art event staged in a particular place every two years. The city of Venice established the first biennial, or 'biennale', in 1895. There are now over three hundred art biennials all over the world, with most established since the 1990s.

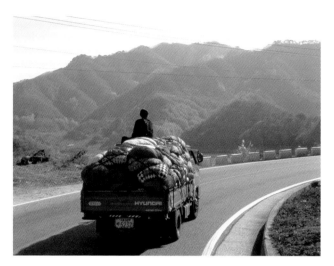

Kimsooja
Cities on the Move: 2,727 Kilometers Bottari Truck, Korea, 1997
Single channel video, 7 minute 3 second loop, silent

Kimsooja's art reflects on issues of migration and displacement. To make this work, she travelled across Korea on a bottari truck, visiting the various places she had lived before moving to New York in the late 1990s.

Organizers of art biennials strive to present the most groundbreaking art in unusual places to get the art world talking

It might take several days of urban exploration to see the whole thing, and even then, you will likely not have watched all the film works! The organizers are under huge pressure to boost the cultural profile of the host location, while also supporting local artists and businesses. In short, biennials are inherently political. A frequent criticism aimed at biennials is the lack of sustained engagement with a place once the exhibition ends. Critics have also mocked the predictable uniformity of art-world events and questioned whether the art world really is as free as it thinks it is. Fair, biennial, fair, biennial. The show must go on.

Reflecting on how the art scene has developed since the 1960s is a useful exercise. It reminds us that art is a marketable commodity, subject to the same trends and pressures as any other area of commerce. Only a very few artists enjoy sustained, lucrative, visible careers. Others enjoy a brief glow of success as their work momentarily chimes with a particular trend. All the artists mentioned in this book fall into one of these two categories; however, it is important to remember that most artists working today will never achieve widespread recognition. They continue to produce art throughout their lives, believing in the power of art and in the value of their contribution. Regardless of the frivolities of art-world fashions and trends, art is, and always will be, an irrepressible and essentially human activity.

KEY IDEAS

Making art is an irrepressible human activity.

Artists today work with a huge range of materials and processes.

Contemporary art can be found in many different settings.

The contemporary art market is a powerful, global force.

KEY ARTISTS

Jean-Michel Basquiat | Daniel Buren | Judy Chicago | Katharina Fritsch | Anselm Kiefer | Barbara Kruger | Ana Mendieta | Sigmar Polke | Julian Schnabel | Lee Ufan

KEY ACTIVITIES

Enlist a friend to join you on your mission to find out more about contemporary art. Have a chat to share your initial interests and draw up a list of exhibitions you would like to see.

Support your local art gallery by visiting an exhibition and attending a related talk or event.

Peter Doig
Blotter, 1993
Oil on canvas
2.6 x 2.1 m
(8 ft 8⅛ in. x 7 ft ⅜ in.)
Walker Art Gallery,
National Museums,
Liverpool

Doig, a Scottish artist based in Trinidad, makes sumptuous paintings exploring the human occupation of landscape. His layered surfaces suggest many undisclosed narratives and art-historical references. Doig has influenced many other painters and his works are highly prized by collectors.

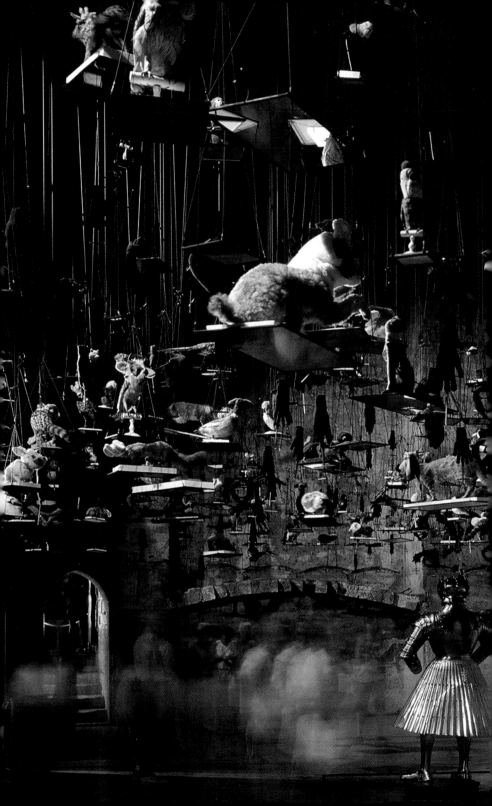

WHAT ARE THE RULES
OF THE GAME?

-

The artist occupies the place of the mischievous
little girl who lives dormant in all of us!

-

Annette Messager, 1989

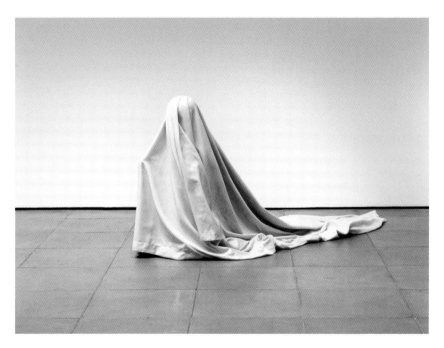

Ryan Gander
*Tell my mother not to
worry (ii)*, 2012
Marble
175 x 60 x 80 cm
(68⅞ x 23⅝ x 31½ in.)

Made from marble, this
evocative sculpture is
one of a series giving
permanent form to the
transient games that
children play. There is
an intriguing contrast
between the makeshift
dens created by Gander's
daughter and the classical
handling of the folded
marble drapery. In this
work, his daughter gives
structure to the cloth by
extending her arms like
a ghost.

Contemporary art can sometimes feel like an insider's game.
With so many one-liners, puns and knowing jibes, the art scene can
feel like the party you're not invited to. Artists appear free to do
pretty much anything they like at any given time. Some seem to
have their tongues firmly stuck in their cheeks. Are they serious,
or is this some kind of joke?

There is certainly an impish spirit to be found within
contemporary art. Artists often incorporate jokes, games and
lightheartedness into their work. They do this to entertain and to
make their art accessible. These playful strategies also raise serious
questions about the social purpose of art, the role of the viewer
and the nature of creativity. This chapter takes a closer look at the
relationship between contemporary art and play. By learning
the rules of the game, we can all join in.

THE LONG GAME

The joke in art is nothing new. There is toilet humour to be found
in the margins of medieval manuscripts and carefully coded sexual
innuendo lurking beneath the surface of Renaissance art. You can
also spot *trompe-l'oeil* (trick of the eye) illusory effects across art
history, with tiny objects appearing so real it is hard to tell if they
are *in* or *on* the painted surface.

Art laughs really took off in the twentieth century. Dada and
Surrealist artworks are full of double meanings and smutty quips.
Marcel Duchamp is perhaps the art world's most notorious prankster.
In 1917 he famously placed a urinal in a gallery and called it art.
Two years later he defaced a reproduction of Leonardo da Vinci's
Mona Lisa, giving her a moustache and a 'hot arse' (*L.H.O.O.Q*,
1919). Let's be clear, Duchamp was very serious about his japery.
He was using jokes to ask searching questions about what art could
be and what materials and actions could constitute art. Duchamp's
radical humour continues to inform the practices and discourses of
contemporary art. Taking a lighthearted view of the world can be
liberating for artists and audiences.

CHILD'S PLAY

The members of society with the most open responses to the world
are children. Children build their knowledge of the world through play.
Their responses have yet to be dampened by cynicism or prejudice.
It is fascinating to observe the large number of artists who have
incorporated a childlike playfulness into their working practices.

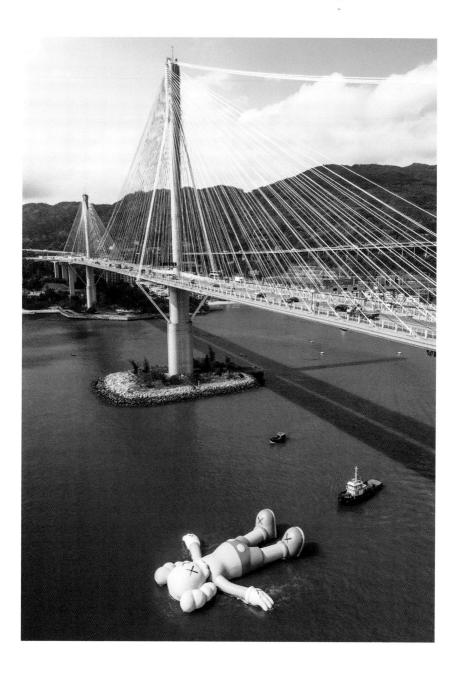

KAWS
HOLIDAY, 2019
Inflatable
Length 37 m
(121 ft 4¾ in.)

This enormous inflatable sculpture represents COMPANION, one of KAWS's most famous characters. With arms outstretched, COMPANION lies on its back and gazes at the sky. KAWS has described how he wanted the work to have an easygoing vibe: 'I wanted to create a work that was really about just relaxing – taking time for yourself and just laying down and looking up.'

This creative energy allows for the free exploration of ideas. Some artists, such as Pilvi Takala, from Finland, and the Swiss artist Ugo Rondinone, have worked directly with children to learn from their creativity.

The British artist Ryan Gander considers his practice to emerge from a process of open-ended playful enquiry. Observing his young children at play has sparked many new ideas and works, including an influential series of marble sculptures that memorialize the makeshift dens and hideaways constructed by his young daughter using furniture and blankets.

Given the strong links between contemporary art and play, it is no surprise to learn that many artists, including Olafur Eliasson, have engaged in the design of playgrounds. Others, including Takashi Murakami from Japan, have incorporated toylike forms and brightly coloured designs into their work. Murakami's appealing visual language is immediately recognizable all over the world, and he is also one of a growing number of artists who have worked with manufacturers to produce limited edition toys. These collaborations blur the boundaries between fine art and shopping, and between unique objects and 'special edition' branded goods. The American artist KAWS has developed similar partnerships with a range of manufacturing companies to develop merchandise, from toys and figures to fashion and soft furnishings. His distinctive work features a cast of cute characters, each with crosses for eyes to create a blank stare. Some of these characters are sourced from his imagination, while others are appropriated from across popular culture.

GETTING INVOLVED

Contemporary artists have used many different methods to maximize the interactive potential of their work, from Carsten Höller's massive slides spiralling down buildings, to Martin Creed's balloon-filled galleries. Creating fun and engaging experiences enables an idea to be shared easily and accessibly. The invitation to participate is clear.

Out with stuffy old gallery rules, and in with multisensory engagement: touch, feel, laugh, squeal

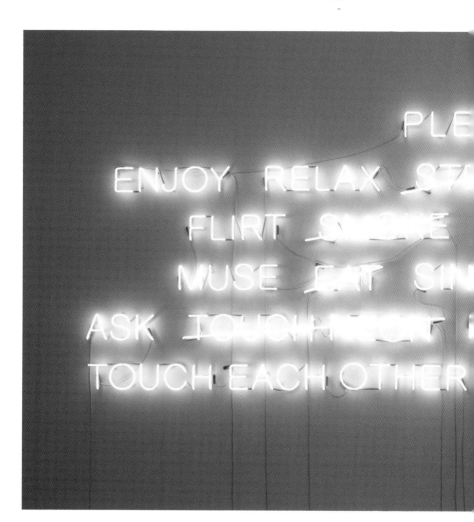

Jeppe Hein
Please ..., 2008
White neon text
1.65 x 4.87 m
(5 ft 5 in. x 15 ft 11¾ in.)

Visitors to galleries are accustomed to adhering to an established set of rules demanding that they do not touch the work, eat or use flash photography. But what if these rules were thrown out of the window and replaced with a more playful and liberating set of instructions? This work proposes exactly that – a responsive and permissive approach to engaging with art.

Positive audience responses boost attendance and reviews. The gallery builds its reputation as a site for fun. It can be a win-win situation ... *if* the fun can be sustained.

Presenting artwork in a public space can enable unlikely interactions in unusual settings. Working beyond the gallery also enables artists to engage with a broader audience. The Thai artist Rirkrit Tiravanija, for example, has pursued various strategies to encourage a level playing field between artist and viewer. A notable series of work involves the presentation of stainless-steel ping pong tables in public parks and plazas to invite social interaction through play. As Tiravanija has explained: 'It is not what you see that is important, but what takes place between people.' Danish artist Jeppe Hein has transformed humble pieces of street furniture to animate public space. These brightly coloured metallic benches can hardly be considered ergonomic. They jut out in all the wrong places, as a way of prompting playful interaction. A relaxing sit down becomes a high-energy workout! Also check out Hein's cheeky water fountains, which shoot jets of water towards unsuspecting bystanders. Contemporary art can re-energize civic space, enabling us to experience the world in fresh ways and forging new social connections.

SERIOUS FUN

Before we get too hooked on utopian visions of shared experiences, let's not forget the many artists who have explored the dark side of humour. Their work can be confrontational and challenging. Have you ever found clowns truly terrifying? If so, you may want to exercise caution when watching *Clown Torture* (1987) by the American artist Bruce Nauman. This influential video installation sees unsuspecting clowns subjected to all kinds of mental and physical discomfort. In observing their misfortune, the viewer becomes implicated in the drama. The work prompts wider reflection on the coercive undercurrents of popular culture and society at large. Nauman's American contemporaries Mike Kelley and Paul McCarthy and the French artist Annette Messager, have also subjected toys and childhood characters to subversive acts and processes to comment on societal issues and behaviours. Their work has inspired successive generations of artists to pursue the subversive potential of play.

Slapstick humour is explored in *Deadpan* (1997), the seminal short film by the British artist and filmmaker Steve McQueen. Based on the famous hurricane scene in Buster Keaton's 1928

Positive audience responses boost attendance and reviews. The gallery builds its reputation as a site for fun. It can be a win-win situation ... *if* the fun can be sustained.

Presenting artwork in a public space can enable unlikely interactions in unusual settings. Working beyond the gallery also enables artists to engage with a broader audience. The Thai artist Rirkrit Tiravanija, for example, has pursued various strategies to encourage a level playing field between artist and viewer. A notable series of work involves the presentation of stainless-steel ping pong tables in public parks and plazas to invite social interaction through play. As Tiravanija has explained: 'It is not what you see that is important, but what takes place between people.' Danish artist Jeppe Hein has transformed humble pieces of street furniture to animate public space. These brightly coloured metallic benches can hardly be considered ergonomic. They jut out in all the wrong places, as a way of prompting playful interaction. A relaxing sit down becomes a high-energy workout! Also check out Hein's cheeky water fountains, which shoot jets of water towards unsuspecting bystanders. Contemporary art can re-energize civic space, enabling us to experience the world in fresh ways and forging new social connections.

SERIOUS FUN

Before we get too hooked on utopian visions of shared experiences, let's not forget the many artists who have explored the dark side of humour. Their work can be confrontational and challenging. Have you ever found clowns truly terrifying? If so, you may want to exercise caution when watching *Clown Torture* (1987) by the American artist Bruce Nauman. This influential video installation sees unsuspecting clowns subjected to all kinds of mental and physical discomfort. In observing their misfortune, the viewer becomes implicated in the drama. The work prompts wider reflection on the coercive undercurrents of popular culture and society at large. Nauman's American contemporaries Mike Kelley and Paul McCarthy and the French artist Annette Messager, have also subjected toys and childhood characters to subversive acts and processes to comment on societal issues and behaviours. Their work has inspired successive generations of artists to pursue the subversive potential of play.

Slapstick humour is explored in *Deadpan* (1997), the seminal short film by the British artist and filmmaker Steve McQueen. Based on the famous hurricane scene in Buster Keaton's 1928

Bruce Nauman
Clown Torture, 1987
Four channel video with sound (two projections, four monitors)
Approximately one-hour loop
Art Institute of Chicago

This immersive video installation is an assault on the senses. The cacophony of noise, combined with the disturbing visual imagery of clowns undergoing torture, is difficult to bear. This work tests the boundaries of humour and pushes the limits of the audience.

Steve McQueen
Deadpan, 1997
16mm film transferred to video (black and white)
4 minutes, 35 seconds

Slapstick takes a serious turn in McQueen's iconic short film *Deadpan*. Repeated over and over again with increasing speed and intensity, the film builds a poignant portrait of resilience and composure in the face of adversity. McQueen elevates the slapstick one-liner to reveal deeper truths.

30

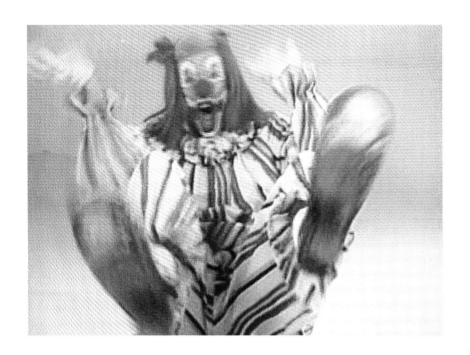

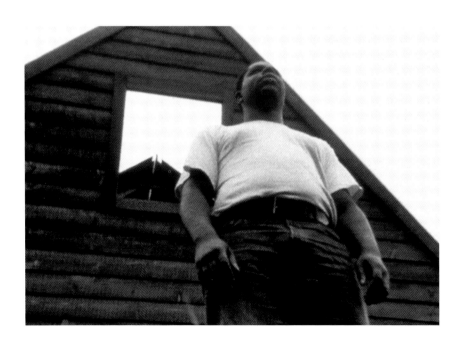

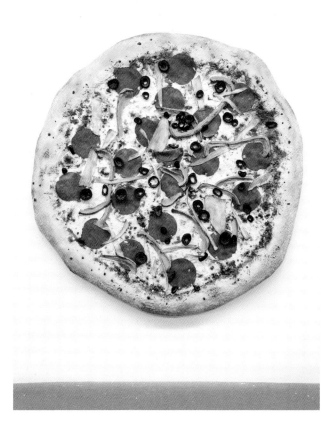

Tom Friedman
Untitled (Pizza), 2013
Styrofoam and paint
218.44 x 218.44 x 12.7 cm
(86 x 86 x 5 in.)

Oozing with pepperoni, vegetables and lashings of cheese, this gigantic pizza looks good enough to eat. The truth, of course, is that this mouthwatering concoction is entirely inedible. Friedman's meticulous fabrication skills prompt the viewer to stop in their tracks, even if only momentarily, to contemplate a parallel universe of unlimited pizza.

movie *Steamboat Bill, Jr.*, McQueen's short black-and-white sequence features the artist standing resolute as a house collapses around him. In presenting himself in the leading role, McQueen comments on the lack of black role models in the history of film. Comedy can be a serious business.

THE LAST LAUGH

This chapter began with a reminder of *trompe-l'oeil* effects in art, Surrealist objects and Marcel Duchamp's shocking 'readymade' interventions. Many artists working today are still concerned with the power of suggestion and repurposing found objects.

Odd-shaped fruit, animals doing funny things and toilet jokes will probably always make us laugh. They also provide opportunities

for artists to keep their work fresh and engaging. Take the work of the American artist Tom Friedman, for example. His playful use of everyday materials has led to mind-boggling objects which fuse wit and intricate craft skills. His works include a full-length self-portrait made from sugar cubes, a perfect sphere moulded from 500 sticks of chewed gum and an awe-inspiring starburst built from 30,000 toothpicks.

British artist Sarah Lucas first hit the headlines in the 1990s for rude sculptures featuring food. In a famous early work, she combined an old table, two eggs and a kebab to suggest a reclining female form. This suggestive reduction of the figure recalls Surrealist art, albeit with added feminist commentary on female representation. Lucas continues to make bawdy sculptures using a wide range of materials. For example, she has stuffed nylon tights with wadding to create squidgy bodily parts including huge appendages and sagging breasts.

Perhaps the last laugh must be reserved for Maurizio Cattelan. This notorious Italian artist is considered by many to be the art world's

Sarah Lucas
DICK 'EAD, 2018
Bronze, concrete and
cast iron
Edition of 6 + 2 APs
172 x 78.5 x 116.5 cm
(67¾ x 31 x 45⅞ in.)

**This recent work is
characteristically bawdy
and uncouth – the artistic
equivalent of a dirty joke.
With sagging folds and
erect protrusions, these
salacious sculptures
recall Lucas's earlier
experiments with
stuffed tights and
phallic foodstuffs. The
use of highly polished
surfaces and traditional
materials such as bronze
gives these works an
old-school glamour and
permanence.**

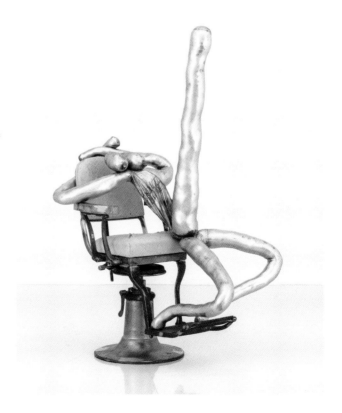

biggest prankster. One of his most audacious acts of recent years was to stick a banana to the wall using duct tape at the Art Basel Miami Beach art fair. Titled *Comedian* (2019), the work, made in an edition of three, sold out on its first day of display: $120,000 per banana, complete with specific instructions for future presentations. *Comedian* provoked an instant global debate on the price and purpose of art. One artist visiting the fair even decided to eat the banana in an act of protest. The banana was quickly replaced. All the fun of the fair.

So, to respond to the initial question, 'What are the rules of the game?' Well, really the answer is that there are none. Contemporary art offers a wide-open arena for play and possibility. There is space to explore materials and ideas. Room to join in and have a giggle. Freedom to explore darker themes and social commentary. The next time you see contemporary art presented in a gallery or in a public space, see if you can spot some of these cues and strategies.

Maurizio Cattelan
Comedian, 2019
Fresh banana, duct tape
Dimensions variable

Comedian caused international outrage when it was first exhibited at Art Basel Miami Beach in 2019. Press and public alike were astonished by this audacious installation and its jaw-dropping price tag. Cattelan enjoys any opportunity for his art to prompt a big reaction: to shock, to enlighten, to amuse.

KEY IDEAS

Many contemporary artists use playfulness and humour to encourage public interaction and engagement.

The free spirit of childhood has provided a source of inspiration. Some artists have designed toys and playgrounds or incorporated simple, colourful imagery.

Humour and jokes can be used to make serious statements about society, politics and human behaviours.

A playful approach has led to the innovative use of humble or everyday materials.

KEY ARTISTS

Jeremy Deller | Jake & Dinos Chapman | Sylvie Fleury | Rodney Graham | Yue Minjun | Yoshitomo Nara | David Shrigley | Ryan Trecartin | Pipilotti Rist | Bedwyr Williams

KEY ACTIVITIES

If you have younger relatives, gain their view of an artwork or exhibition; their ideas can be enlightening.

Engage in a little 'window shopping' and check out the online market for artists' merchandise.

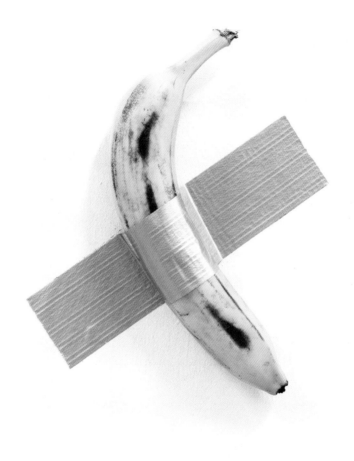

CARSTEN HÖLLER
BORN 1961, BRUSSELS, BELGIUM
Lives and works in Stockholm, Sweden, and Biriwa, Ghana

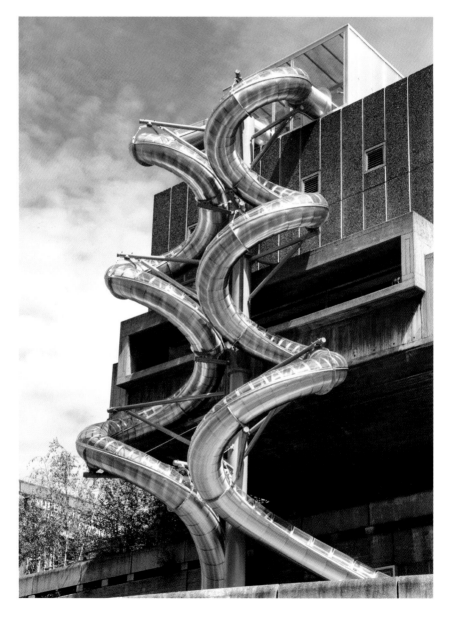

Carsten Höller
Isomeric Slides, 2015
Installation
Hayward Gallery, London

Two slides were installed at the Hayward Gallery at the time of Höller's major exhibition 'Decision' (2015). At the end of the exhibition, visitors could choose a slide to transport them back to ground level. The slides offered a final exhilarating and memorable experience: a high-speed ride down the exterior of the building.

For Carsten Höller, an exhibition should be an interactive site for experimentation. Höller's playful installations demand our full physical participation: they spin us round, make us fly and turn our world upside down, before dumping us out by the exit. In 2006, Höller transformed the galleries of MASS MoCA into an *Amusement Park*, confounding the audience by slowing down all the rides to a snail's pace. His *Upside-Down Goggles* (2009–11) had a similarly disorientating effect, upturning the view of each wearer. By literally moving and shaking his audience, Höller invites us to see the world from different perspectives. If we open ourselves to new experiences often enough, could the effects be life changing?

Perhaps Höller's best known works involve enormous and elaborate slides. These polycarbonate and resin tubular structures curve dramatically around major museums and galleries. Visitors are invited to take the plunge, to lose control, to scream, to laugh. When using one of Höller's slides, it is possible to experience a full spectrum of emotions from fear to joy in a matter of seconds. As Höller has explained, a slide is a 'device for experiencing a unique condition somewhere between delight and madness'. He considers a slide to be a 'sculpture you can travel inside'. Shooting through the tube at high-speed challenges our understanding of gallery behaviour and pace. We are used to a slow, ponderous amble, or a gentle glide up an escalator, not a turbocharged bolt.

Höller made his first slides for the Berlin Biennale in 1998. In 2006 he devised an elaborate scheme of five slides for the Turbine Hall in Tate Modern, London. Titled *Test Site*, this dynamic installation invited audiences to trial different types of slides. The gallery became an experiment, with the public driving the data.

––––––––
KEY FACTS

Carsten Höller never attended art school. He trained as a scientist and holds a PhD in Biology, working as a research entomologist until 1994.

In 2000, Höller was invited by the Italian fashion designer Miuccia Prada to install a slide at her Milan headquarters so that she could travel from her office to her car in style.

––––––––
KEY WORKS

Upside-Down Mushroom Room, 2000, installation at MOCA, Los Angeles, USA, 2005–6

Amusement Park, 2006, installation at Massachusetts Museum of Contemporary Art (MASS MoCA), North Adams, USA, 2006

ANNETTE MESSAGER
BORN 1943, BERCK, FRANCE

Lives and works in Malakoff, France

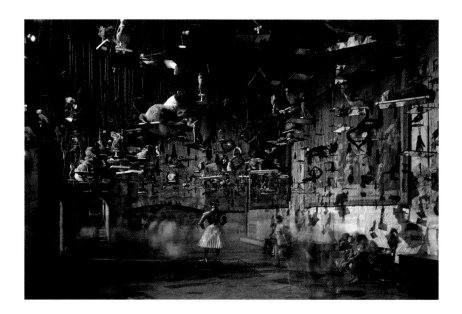

Annette Messager's work is intentionally playful and impishly
deviant. It resists easy categorization and refuses to conform to
established genres. As an art student in the late 1960s, Messager
took strength from the radical feminist and Conceptual Art ideas
in circulation. These liberating principles provided a framework in
which she could develop her own unique approach.

Messager draws inspiration from a vast range of cultural
sources, from astrology and occultism to Symbolism, Surrealism
and Outsider Art. She also embraces a broad spectrum of fiction,
including fairy tales, myths and films. Messager's approach to
materials is similarly diverse. As she has explained: 'I like bric-a-
brac, tinkering around, making different genres collide.' She has

produced prints, photographs, drawings and books, and has also created dramatic large-scale installations incorporating dolls, teddies, puppets and taxidermized animals and birds. These innocent forms assume a sinister presence when stuffed, strung and snared in apparently violent and degrading ways. Propped on sticks or left dangling from the ceiling, these childish things appear poised between life and death. They take centre stage in a very adult kind of theatre, at once grotesque, horrifying and wilfully absurd.

Messager's art touches on personal memories and experiences, but it also has political and historical implications. As a woman, Messager considers herself to be a marginalized artist. Ironically, being ignored has provided space and opportunity for deviation and freedom of expression.

Annette Messager
Eux et Nous, Nous et Eux,
2000
Gloves, coloured pencils, mirrors, stuffed animals and plush toys
Dimensions variable

This extraordinary installation was made for the exhibition 'La Beauté', which took place across Avignon, France, in 2000. Messager responded to the elaborate wallpapers in the Popes' Palace by creating a multitude of taxidermized creatures with soft-toy heads. Each hybrid character perched on a mirrored platform suspended from the ceiling. Visitors were invited to walk beneath this airborne spectacle.

KEY FACTS

Annette Messager represented France at the 51st Venice Biennale in 2005. She was awarded the Golden Lion for her immersive installation *Casino* (2004–5), which was based on the story of Pinocchio.
In 2016, Messager won the prestigious Praemium Imperiale International Art Award for sculpture.

KEY WORKS

Les Pikes (The Pikes), 1992–3, installation, Centre Pompidou, Paris, France
Petite Babylone, 2019, Marian Goodman Gallery, New York, USA, and Paris, France

TAKASHI MURAKAMI
BORN 1962, ITABASHI CITY, TOKYO, JAPAN

Lives and works in Tokyo, Japan, and New York, USA

It is easy to understand why Takashi Murakami is frequently compared to the Pop artist Andy Warhol. Like Warhol, Murakami has looked to high and low culture for inspiration, and he has maximized the commercial potential of his art. Warhol established his 'Factory' in a loft in New York City, employing others to maintain a prolific output. Founded in 2001, Murakami's Tokyo-based trading company Kaikai Kiki Co. Ltd currently employs hundreds of people to produce and market his work.

Murakami's interest in Japanese culture spans a wide range of genres, from traditional flower painting to the latest *anime* and *manga* releases. Sampling elements from each source, Murakami creates his own unique visual language. His art is brightly coloured, with a 'superflat' comic-book precision. His imagery features a huge cast of characters, including DOB, who often represents the artist himself. There is a childlike innocence to the imagery and a clear interest in the Japanese concept of *kawaii* or 'cuteness'. However, this sugary sweetness barely conceals the presence of adult themes and sinister undercurrents.

Murakami makes paintings and sculptures for significant galleries and museums. His major touring exhibition '© Murakami' took to the road for two years from 2007–9, travelling to Los Angeles, New York City, Frankfurt and Bilbao. Murakami is also famous for producing a remarkable range of merchandise, from T-shirts and bedspreads to mouse pads and snack toys. A collaboration with the fashion house Louis Vuitton (2003–15) led to an exclusive range of handbags and holdalls. Apart from the price tag, there is little to distinguish Murakami's art from his merchandise: each item shares the same signature style, the same distinctive imagery. Without recourse to irony, Murakami reminds us of the close connections between art and commercial enterprise, both resulting from our commodity-driven society.

Takashi Murakami
Flower Ball (3-D), Kindergarten, 2007
Acrylic and silver gold leaf on canvas mounted on board
100.3 x 100.3 cm (39½ x 39½ in.)
Gagosian Gallery, New York

Murakami considers flowers to be both alluring and predatory. In this painting, the smiling blooms could be interpreted as cute, yet this grinning crowd could equally be considered threatening. Murakami's interest in juxtapositions can also be found in the combination of his trademark 'superflat' picture surface with the overall suggestion of a spherical form.

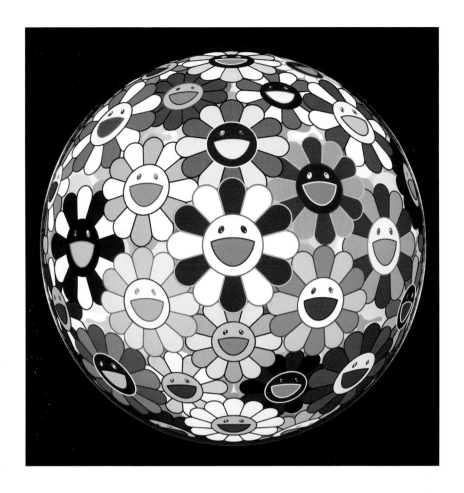

KEY FACTS

Takashi Murakami gained a PhD from the Tokyo National
University of Fine Arts and Music. His education included
extensive training in *nihonga* – traditional Japanese painting.

In 2001, Murakami curated the group exhibition 'Superflat' at
the Museum of Contemporary Art in Los Angeles, which featured
the work of artists influenced by the flat aesthetic of Japanese
culture.

Murakami's art is often termed Post-Pop or Neo-Pop because of
its close connections with Pop Art.

KEY WORKS

727, 1996, Museum of Modern Art, New York, USA

Invoking the Vitality of a Universe Beyond Imagination, 2014,
Gagosian Gallery, New York, USA

UGO RONDINONE
BORN 1964, BRUNNEN, SWITZERLAND

Lives and works in New York, USA

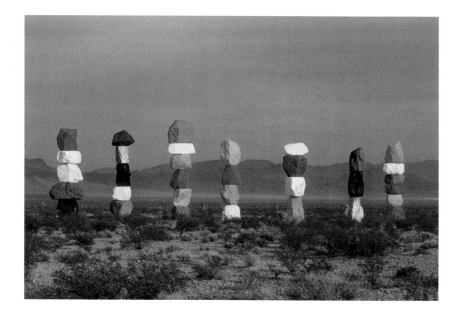

There is a childlike quality to Ugo Rondinone's art: a sense of awe
when confronted with the natural world, a clear joy in simple blocks
of colour, and an honesty and directness. Rondinone once said:
'All artists keep wonder alive. Art starts within childhood. As an
artist you feed from childhood memories. Many artists retreat
as children and build up their own world. Their art reveals this.'
Rondinone is keen that his art is easily understood. Avoiding
complex intellectual positions, he instead incorporates familiar
imagery and encourages direct personal engagement: 'I always
say that you don't have to understand an artwork. You have just
to feel it. In my work I use very basic raw symbols, something that
everybody can relate to, from a child to an old person, from the
East to the West.'

Rondinone works across many different media. Much of his work
focuses on the relationship between nature and artifice, logic and
irrationality. He has drawn considerable inspiration from German
Romantic Art, which connected sublime visions of nature with

Ugo Rondinone
Seven Magic Mountains,
2016
Seven dayglow totems
comprised of painted,
locally sourced boulders
Height, each 9.14–
10.66 m (30–35 ft)
Las Vegas

**Towering over nine
metres tall, this massive
installation is the largest
land-based artwork to
be produced in the USA
in over forty years. Each
boulder weighs between
ten and fifteen tonnes.
The work took almost
five years to complete
and involved a complex
set of technical and legal
negotiations.**

Ugo Rondinone
Hell, Yes!, 2001
Neon, Perspex,
translucent film,
aluminium
7.3 x 2.8 x 0.15 m (24 ft
1 in. x 9 ft 3⅞ in. x 6 in.)

**Since 1997, Rondinone
has sited a series of
arching rainbow neon
signs in public spaces.
Each sign features a
positive affirmation
sourced from popular
music or everyday
life. The rainbow
is a meteorological
phenomenon that
continues to inspire
feelings of joy, love and
hope. The rainbow flag
represents LGBTQIA+
pride and celebrates
the diversity of human
sexuality and gender.**

strong human emotions. Rainbow motifs recur across Rondinone's work, in colourful airbrushed paintings and arching neon signs spelling out positive phrases. Rondinone has also invited groups of school-aged children from Mexico to Moscow to produce their own images of rainbows and suns. These collective displays convey a powerful message of positivity and hope.

Mountains have provided another important source of inspiration. Rondinone's spectacular installation *Seven Magic Mountains* (2016) comprises seven vertical stacks of locally sourced limestone boulders, each coated with a luminous shade of fluorescent paint. Located just off the freeway between Las Vegas and the Mojave National Preserve, with the McCullough Range visible in the distance, this awe-inspiring work operates as a bridge 'between human and nature, artificial and natural, then and now'.

KEY FACTS

In 2013, Ugo Rondinone presented *Human Nature,* a major piece of public art outside the Rockefeller Center in New York. The work featured nine gigantic bluestone figures that hovered over the urban landscape.

For his exhibition 'Vocabulary of Solitude' at the Museum Boijmans Van Beuningen, Rotterdam in 2016, Rondinone arranged forty-five life-size clown mannequins to act out different human emotions.

KEY WORK

Liverpool Mountain, 2018, Tate Liverpool, UK

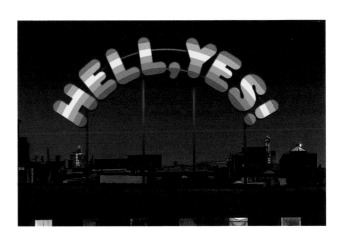

PILVI TAKALA
BORN 1981, HELSINKI, FINLAND

Lives and works in Berlin, Germany, and Helsinki, Finland

Pilvi Takala is interested in rules: not the formal, written sort, but the unspoken behaviours and customs that we learn gradually and subconsciously. Takala explores the confusion of visiting a place with unfamiliar customs, stating 'I like being somewhere unpredictable.' After meticulous research, she enters a new everyday context, testing accepted boundaries by engaging in impish and gently disruptive actions. In 2008, she undertook a traineeship in the marketing department of Deloitte, Helsinki. She spent a month roaming, idling and staring, much to the bafflement and frustration of her colleagues.

Some of Takala's most memorable performances emerge from a spirit of wilful naivety. In the short film *Real Snow White* (2009), Takala dressed up as the famous Disney character and joined the queue in the hope of purchasing a ticket to enter Disneyland Paris. Her hopes were dashed by several diligent security guards who made it clear that her presence was problematic. Struggling to explain their reasoning, they concluded that she would undermine the 'real' Snow White in the park, and they also considered it unacceptable for an adult to wear full costume. Takala had pushed invisible boundaries, uncovering unwritten rules.

In 2013, Takala won a prestigious EMDASH Award, which recognizes emerging talent in Performance Art. Working with Frieze Foundation and an educationalist, she facilitated several workshops for a youth club of eight- to twelve-year-olds in Bow, East London. The children formed a committee tasked with deciding how to spend £7,000 of her prize money. After much discussion, the committee announced they would spend the cash on a 'five-star bouncy castle'. The play equipment was duly installed for everyone to enjoy. *The Committee* (2014) fuses an interest in childhood play and aspiration with the responsibilities and skills required for decision making.

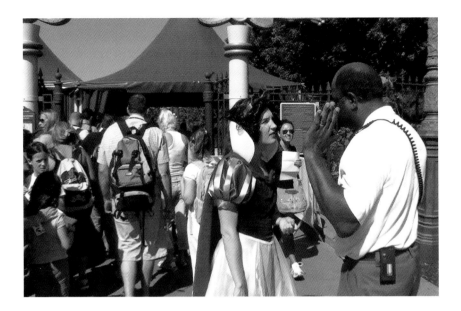

Pilvi Takala
Real Snow White, 2009
Video
9 minutes 19 seconds

**Takala's arrival at
Disneyland Paris caused
quite a stir. Impeccably
dressed as Snow White
she walked purposefully
to the back of the
queue, interrupted only
by children requesting
her autograph and
parents wanting a group
photograph. She was
quickly intercepted by
officials, who argued,
'Only the real Snow
White can dress like this.
You cannot do it.'**

KEY FACTS

In 2013, Pilvi Takala won the Finnish State Prize for Visual Arts.
In 2022, Takala represented Finland at the 59th Venice Biennale.
 She exhibited a newly commissioned video installation, *Close
 Watch*, based on her direct engagement with the security
 industry.

KEY WORKS

The Trainee, 2008
The Committee, 2014

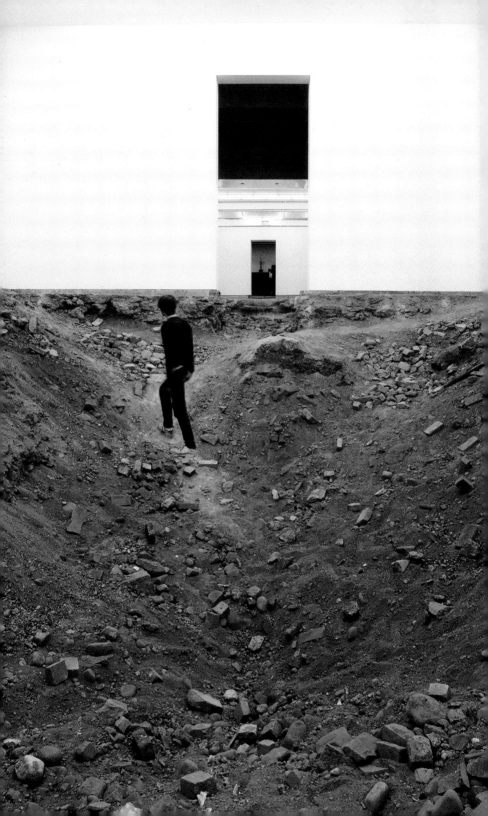

WHY MAKE SOMETHING OUT OF NOTHING?

-

Art always has room for anything
and everybody. Art is whatever you allow
it to be, as an artist or a viewer

-

Urs Fischer, 2020

One of the most familiar gripes about contemporary art is that there isn't much to see. Why do artists get away with doing so little? How can a small fleck on a canvas, an empty room, or a slight gesture possibly be called art? Where is the skill? And anyway, surely a five-year-old *really could* do that? The 'Emperor's New Clothes' accusation springs up repeatedly, from gallery feedback forms to newspaper columns and social media threads. It sometimes feels much easier to join in with the dismissal of contemporary art than to spend time finding out the reasons *why* artists are so interested in a light touch. This chapter will explore some of the ways in which artists have explored different kinds of nothingness, from empty spaces to fleeting moments. Some artists have used perishable materials to express an idea. Others have made work so indistinguishable from everyday life that it virtually goes unnoticed. There are works that transport the viewer to a quiet, meditative place, enabling us to marvel at the beauty and vastness of the universe. From the micro to the macro and back again, these works touch on what it is to be human.

NOTHING TO SEE HERE

The subject of nothingness has fascinated artists for a very long time. Kazimir Malevich's famous work *Black Square* (1915) took abstract painting to a 'zero point', which the Ukrainian artist defined as 'liberated nothingness'. In the 1960s, Minimalism reduced the language of sculpture to modular, repetitive units presented in ways that highlighted not just the work itself but also the surrounding space.

The international flowering of Conceptual Art led to a belief in the *idea* as the key driver of art. A brief performance (whether witnessed or not), a written text, or even the way you prepared a meal, could all be considered art.

Conceptual artists hoped to free themselves from the clutches of the art market by refusing to produce saleable objects. This approach often went hand in hand with a conscious rejection of making. In 1969, the American Conceptual artist Lee Lozano presented *Untitled (General Strike Piece)*, which involved her total abstinence from the art world. Her later and even more extreme work *Dropout Piece* (begun c.1970) saw her leave social life for good. The emergence of Land Art led to an expansion of opportunities beyond the urban context. *A Line Made by Walking* (1967), by Richard Long, marks a particularly light-touch engagement with nature. To create this work, Long walked up and down a British

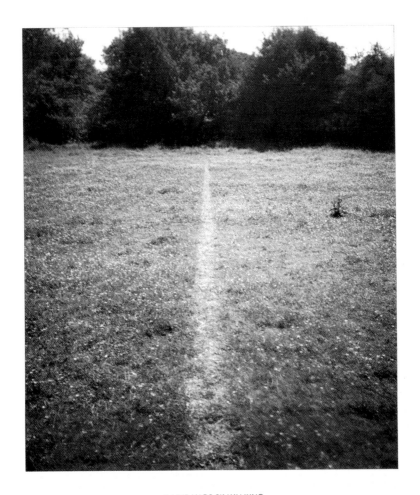

A LINE MADE BY WALKING

ENGLAND 1967

Richard Long
A Line Made by Walking,
1967
Photograph, gelatin
silver print on paper and
graphite on board
37.5 x 32.4 cm
(14⅞ x 12⅞ in.)
Tate Gallery, London

**On one of his many
commutes from Bristol
to London as a student,
Long decided to stop off
and walk up and down a
Wiltshire field until his
footsteps became visible.
This intervention spans
Minimalism, Land Art
and Performance Art.**

field until a gentle line became visible. This influential intervention acknowledges the influence of Minimal and Conceptual Art. It also proposes artmaking as mobile, fleeting and subject to change.

VANISHING ACTS

With the erosion of all fixed notions of how art should be made and presented, contemporary artists have embraced many experimental and light-touch processes, including the use of ephemeral materials. Urs Fischer, for example, has incorporated fruit, bread, vegetables and candle wax to create sculptural installations that decay, ooze and wilt in time. In Karla Black's work, thin polythene sheets and light dustings of cosmetic powders create ethereal visions never intended to last.

-

**Perishable materials embody ideas of transience
and precariousness**

-

The Belgian-born, Mexico-based artist Francis Alÿs undertakes fleeting and seemingly futile actions in public spaces, often engaging others. He once invited a street cleaner to sweep cigarette butts into a line spanning Mexico City's vast main square the Zócalo.

Francis Alÿs
*Paradox of Praxis 1
(Sometimes Making
Something Leads to
Nothing)*, 1997
Video, 5 minutes,
colour, sound

This short film features Alÿs moving a block of ice around the streets of Mexico City. Progress is tricky at first, as he struggles to push and coax the lump along. Gradually, he is able to kick the cube easily before it finally disappears into the tarmac. Alÿs considers the work to be 'a settling of accounts with minimalist sculpture'.

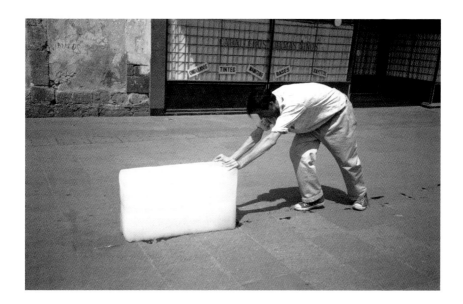

Felix Gonzalez-Torres
'Untitled' (Portrait of Ross in L.A.), 1991
Candies in variously coloured wrappers, endless supply
Overall dimensions vary with installation, ideal weight 175 lb

This 'allegorical portrait' references the artist's partner, Ross Laycock, who died of AIDS in 1991. Weighing 175 lb, the work can be understood to reflect Ross's weight prior to illness, and alludes to the approximate weight of a healthy individual. As the public takes the candy, the portrait undergoes a poignant shrinking process.

He also employed 500 young people armed with shovels to spend the day moving a mountain outside Lima. Alÿs's work often involves moving around a particular location, leaving delicate traces behind him. He once untangled a jumper while walking, releasing the woollen thread to map his progress, and he has also walked a route with a dripping can of paint.

The Cuban-born American artist Felix Gonzalez-Torres was also interested in finding poetry in the mundane. A spirit of generosity underpins his art. His understated installations invite participation: visitors are permitted to take a candy from the glistening pile or remove a poster from the minimal stack. Own your own piece of art. Eat it. Display it. He also presented some of his work in public spaces so that it could be accessed by more people. Much of Gonzalez-Torres's work reflects upon his life as a gay man during the AIDS crisis and touches on issues of love, loss and the passage of time. Aware of his own limited lifespan, Gonzalez-Torres prepared meticulous procedures and instructions to secure a legacy for his art. His elegant, emotive works remain a huge source of inspiration to many artists working today.

CLEARING THE ROOM

A surprising number of artists have taken inspiration from the creative potential of an empty room. There have been several major international exhibitions, including 'Voids: A Retrospective' at the Centre Pompidou, Paris (2009), which featured successive empty rooms interrupted by the slightest interventions. The South Korean

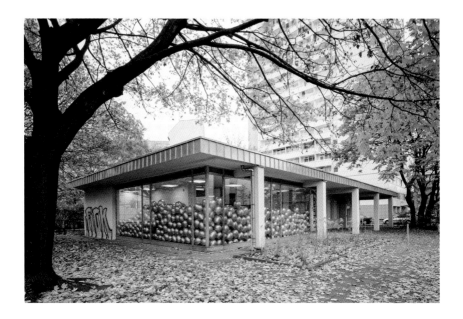

artist Do Ho Suh has made detailed textile reconstructions of his former homes. The prize for the sparsest room, however, should perhaps go to the British artist Martin Creed, who scooped the Turner Prize back in 2001. His sole presentation of *Work No. 227, The lights going on and off* (2000) caused shockwaves across mainstream media. The work comprised an entirely empty gallery space with lights switching on and off at five-second intervals. A master of indecision, Creed makes work from humble materials, including screwed-up pieces of A4 and balls of Blu Tak. His balloon installations fill fifty percent of a given space, making it neither full nor empty. Creed's work acts as a philosophical inquiry into presence and absence, action and rest. His work also invites us to reflect upon what art can add to the world.

Rachel Whiteread's response to empty space is to fill it! Since the 1990s, Whiteread has received international recognition for casting the inside of things. Starting off with the internal volumes of hot water bottles and mattresses, Whiteread quickly moved on to larger spaces: the inside of a room, a stairwell, even a whole house. Although now demolished, *House* (1993) maintains a significant place in contemporary art history. Whiteread's cast of the inside of an East London terrace acts as a kind of ghost memorial to absence and loss. Its melancholy grey form captured every nook and cranny of an abandoned dwelling.

Martin Creed
Work No. 360, Half the air in a given space
2004
Silver balloons.
Multiple parts, each balloon 40.6 cm (16 in.) diameter; overall dimensions variable.

Work No. 360 is one of a series of installations in which half the air of a given space is captured within thousands of balloons.

Rachel Whiteread
House, 1993

Whiteread's fusion of tough minimal form and rich human content has attracted global recognition. Whiteread was the first woman to win the Turner Prize, in 1993, for this cast of a London terraced house.

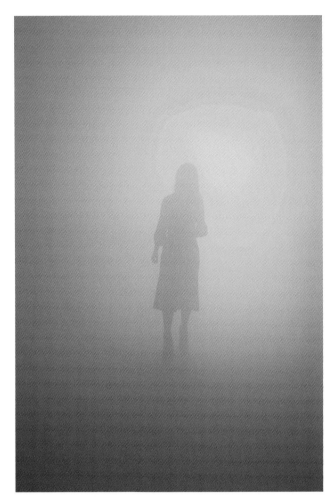

Olafur Eliasson
Din blinde passager (Your blind passenger), 2010
Fluorescent lamps, monofrequency lamps (yellow), fog machine, ventilator, wood, aluminium, steel, fabric, plastic sheet
3.3 x 2.7 x 96 m
(10 ft 10 in. x 8 ft 10⅜ in. x 314 ft 11⅝ in.)

Eliasson is renowned for his immersive installations which harness the effects of light, water and temperature. 'Din blinde passager', which translates as 'your blind passenger' – the Danish term for a stowaway, uses fog and lights to restrict viewers' visual perception as they move through a long narrow passageway, inviting them to find other ways to navigate the space.

INTO THE VOID

Gazing at a clear sky or a calm sea can take us beyond ourselves, to dreamy realms of quiet contemplation and infinite calm. Various artists have sought to capture this meditative state using the powerful effects of light and colour. Artists including Olafur Eliasson, Roni Horn and James Turrell have taken direct inspiration from natural phenomena to create experiential and immersive installations. On the outside, Eliasson's *Din blinde passager* (2010) looks like a workaday stage set or a makeshift corridor. Take a step inside, however, and you will find yourself in a dense, yellow fog made from fog machines and mono-

Susan Philipsz
*War Damaged Musical
Instruments*, 2015
Dimensions variable

**Made to mark the
centenary of the First
World War, this work
comprises fourteen
recordings from German
and English brass and
wind instruments
damaged in conflict.
Philipsz has reflected,
'I am less interested in
creating music than to
see what sounds these
instruments are still
capable of, even if that
sound is just the breath
of the player.'**

frequency lamps (yellow). Unable to see far ahead, disorientated
participants must use their other senses to navigate the space.
As the artist explains: 'Take away the sense of sight and suddenly
things are not so simple.'

Adding sound to an empty space is another way of moving
beyond object making and towards new narratives and
encounters. Susan Philipsz is known for her meditative sound
installations which often incorporate music and song. *War
Damaged Musical Instruments* (2015) is a haunting example
of her work. Initially installed in Tate Britain's expansive
Duveen Galleries, the work comprised a minimal installation of
speakers suspended from the ceiling. Each speaker emitted the
sorrowful sound of a lone brass or wind instrument damaged
during conflict, some so battered they expired just a breathy
gasp. Together, this weary orchestra managed a melancholy
rendition of the classic bugle call, *The Last Post*. Susan Philipsz's
work indicates how an empty space can be filled with rich and
resonant, albeit invisible, content.

OUT OF THE ORDINARY

Sometimes, art can be so like everyday life that it can escape notice. In 1993, the Mexican artist Gabriel Orozco submitted an empty shoe box as his contribution to the 45th Venice Biennale. An empty space within an empty space, this unassuming object was overlooked by some, kicked about by others and even thrown out with the trash. Orozco enjoyed the fragility of the object and its openness to interaction and comment. The box became a receptacle for ideas and conversations in real time.

Roman Ondák has used performance to enliven the gallery space in subtle and deliberately banal ways. To make *Good Feelings In Good Times* (2007), Ondák employed a group of volunteers and actors to stand in an informal queue in an unremarkable area of the gallery. Again, the work risked being overlooked. However, for those in the know, this fleeting performance commented on the nature and value of the spectacle, while also touching on Ondák's childhood memories of queuing at food shops in communist Slovakia. Deliberately unspectacular, these works reveal how ideas can flourish without expensive materials or extensive training. However, to discern this humble art, we must remain alert.

Fragments from everyday life can assume poetic significance when transposed into another medium. The Belgian painter

Gabriel Orozco
Empty Shoe Box, 1993
Shoe box
12.4 x 33 x 21.6 cm
(5 x 13 x 8⅝ in.)
Museum of Modern Art,
New York

When is an empty shoe box an empty shoe box and when is it an art installation? In the hands of Orozco, an empty shoe box becomes a kind of time-based performance. Kicked about, thrown in the trash, eyed with suspicion, the box takes on a life of its own, subjected to forces beyond its control.

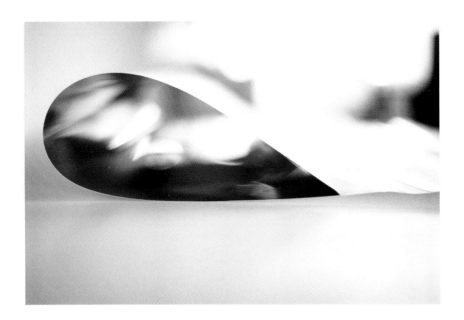

Wolfgang Tillmans
paper drop (London),
2008
C-type print
50.8 x 61 cm
(20 x 24 in.)
Arts Council Collection,
Southbank Centre,
London

This work is one of a large
series of photographs
focusing on lightly folded
paper. Tillmans has
acknowledged that 'paper
is the material basis of
almost all my work. In
2000 I began making it
the subject of my work
and, soon after, I started
making pictures of glossy
photographic paper itself,
which I had exposed to
specific coloured light
before processing it.'

Michaël Borremans, for example, depicts people engaged in
seemingly mundane activities such as making a sandwich, sitting
or sleeping. When represented in paint these inconsequential
actions suddenly assume a new importance.

Let's compare two recent works of art; each responds
to a seemingly inconsequential piece of paper. *Paper drop
(London)* (2008) by the German artist Wolfgang Tillmans
reveals the artist's technical competence as a photographer.
His representation of a simple leaf of paper folding onto itself
becomes a graceful abstraction, a succulent swoosh, almost
painterly in its sensitive handling of colour and form. Alison
Watt's painting *Warrender* (2016) is equally skilful. Exquisitely
rendered in oil paint, this haunting image of an unfolded page
conveys an almost devotional intensity. Both works reflect on
the sculptural processes of folding and tactility, and both emerge
from a deep scrutiny of the mundane. There is beauty to be
found in the unlikeliest of places. In the hands of contemporary
artists, nothings can become somethings and some things turn
to nothing.

KEY IDEAS

Minimal and Conceptual Art continue to influence artists
working today.

Many artists have used empty space to convey new meanings
and ideas.

Contemporary artists have often used ephemeral materials to
explore notions of mortality and vulnerability.

Artists have used light and sound to animate empty spaces,
creating immersive experiences.

KEY ARTISTS

Michael Asher | Maria Eichhorn | Ceal Floyer | Isa Genzken |
Thomas Hirschhorn | Alfredo Jaar | On Kawara | Laurie Parsons |
Anish Kapoor | James Turrell

KEY ACTIVITIES

Choose an artwork or concept from this chapter that you find
particularly challenging and carry out some further research
online or in a library.

Listening to an artist talk about their work can be a helpful way
of deepening understanding. You can find lots of interviews
with artists online. www.art21.org is a good place to start.

Alison Watt
Warrender, 2016
Oil on canvas
122 x 91.5 cm
(48⅛ x 36⅛ in.)
Arts Council Collection,
Southbank Centre,
London

This work references a
seventeenth-century
still life painting by
Thomas Warrender in the
collection of the National
Galleries of Scotland.
Warrender's *trompe-l'oeil*
representation of a letter
rack is the only work by
the artist in existence.
Watt responded
with a meticulous
representation of a crisp
sheet of white paper
folded into quarters.

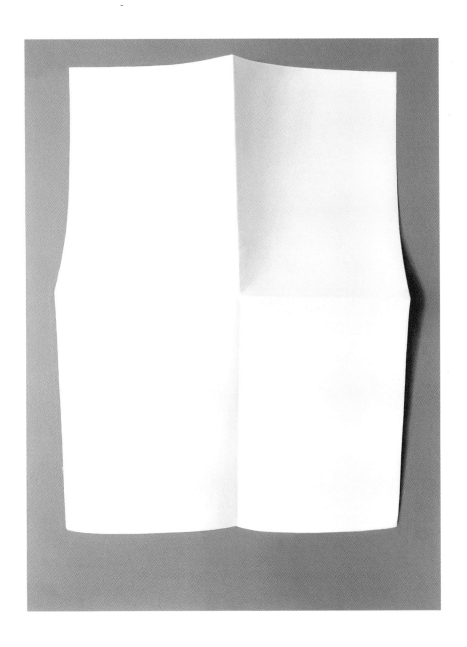

KARLA BLACK
BORN 1972, ALEXANDRIA, SCOTLAND

Lives and works in Glasgow, Scotland

Art does not have to last forever to be powerful. Sometimes the most short-lived interventions linger longest in the memory. Karla Black makes sculpture using substances that are not designed to last. She combines traditional art materials such as paper, plaster, paint and pigment with unconventional products such as toothpaste, body lotion, eyeshadow and spray-tan to create immersive and evocative works. Her pastel-coloured accumulations appear vulnerable – at risk from a sudden breeze or misstep. Suspended from the gallery ceiling or seeping across the floor, Black's work assumes a quiet authority.

Black considers her art to be abstract. She responds to formal relationships of light and colour, space and mass. Her work digs deep into the histories and site-specific properties of Land Art. It also reflects her childhood memories of digging and making: delving in, hands dirty, learning through touch. There is a strong spirit of performance; the work emerges from an energetic set of actions and impulses. These gestures have a painterly quality reminiscent of Abstract Expressionism. Black enjoys the freedom of this in-between space: 'almost painting, almost installation, almost performance art'.

Each of Black's selected materials has distinctive properties to be celebrated. The pure pastel colour and sensuous lustre of an eyeshadow, for example, can exceed the shimmer and hue of traditional paint. Black does not consider cosmetics to be inherently feminine: she may have first-hand experience of using them, but so do many men. Cosmetics do, however, offer a promise of transformation. They are bound up with longing. As Black has explained, 'I tend to think of the materials as something I can't help but use, something that comes out of desire, out of the unconscious.'

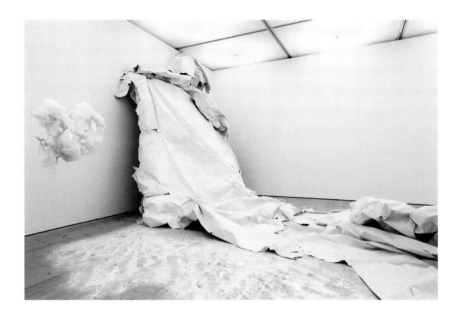

Karla Black
Doesn't Care In Words,
2011
Cellophane, paint,
Sellotape, sugar paper,
chalk, powder paint,
plaster powder, wood,
polystyrene, polythene,
thread, bath bombs,
petroleum jelly,
moisturising cream
Dimensions variable

**Black made this
ambitious work for her
Turner Prize exhibition
at BALTIC Centre for
Contemporary Art,
Gateshead. It featured
an extensive range of
malleable materials which
she draped, slumped,
hovered and scattered
across the gallery. Her
trademark choice of
an ambiguous title
deliberately prevents a
singular interpretation.**

KEY FACTS

Karla Black grew up in a working-class community in Scotland.
 She first became interested in art when visiting galleries
 with her older brother in Glasgow. Black studied Sculpture
 at Glasgow School of Art (1995–9) and went on to gain
 postgraduate qualifications.
In 2011 Black was shortlisted for the Turner Prize and
 represented Scotland at the 54th Venice Biennale.

KEY WORKS

Make Yourself Necessary, 2012, Solomon R. Guggenheim Museum,
 New York, USA
Waiver for Shade, 2021, Galerie Gisela Capitain, Cologne,
 Germany, and Modern Art, London, UK

MICHAËL BORREMANS
BORN 1963, GERAARDSBERGEN, BELGIUM

Lives and works in Ghent, Belgium

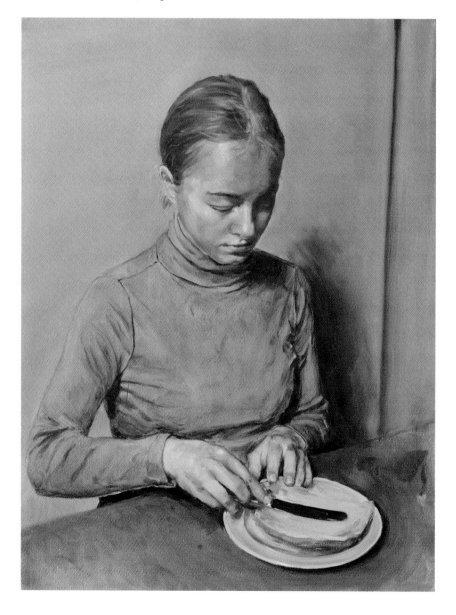

In a 2016 interview for *Apollo* magazine, Michaël Borremans attempted to summarize his practice: 'You cannot place it, you cannot catalogue it, you cannot define it, and otherwise it looks very charming.' His beautifully baffling paintings depict men, women and children in strangely dislocated settings, like players on a stage. His anonymous protagonists refuse to return our gaze and instead cast their eyes downwards to focus on ritualistic or seemingly mundane activities. Sometimes their eyes close fully as if sleeping, or perhaps dead. Who are these people and what is going on? Are they visitors from history or inhabitants of a sinister present?

Borremans maintains a deep respect for art of the past. He admires the work of Édouard Manet, Diego Velázquez and Francisco de Goya. The influence of Dutch painting and seventeenth-century portraiture can also be discerned. Borremans's brushwork is sensuous and fleeting. His choice of colour is deliberately understated: dull creams, dirty pinks and rich browns suck the viewer into muted dramas. There is a strong cinematic quality at play in these works, and a clear acknowledgment of the importance of photography. Initially, Borremans used photographs from the 1930s and 1940s as his source material. Concerned that his paintings might be misconstrued as nostalgic, he now works with life models in his studio. He asks them to strike specific poses wearing carefully selected outfits before capturing them on camera. Borremans works from the resulting photographs, but he views the image on a screen positioned some distance from the canvas to prevent slavish copying. Searching for stories, answers and definitive meanings in Borremans's work is a fruitless task because the real driver of the work lies in the process: 'I make paintings because my subject matter, to a large extent, is painting.'

Michaël Borremans
The Cheese Sandwich,
2019
Oil on canvas
80 x 60 cm
(31½ x 23⅝ in.)
Private collection

This painting is one of several works in which a figure sits at a table and undertakes close work using their hands. Neatly dressed, the protagonists appear solemn, eyes cast downwards to focus on their work. Their gaze directs our attention to private rituals. Captured meticulously in oils, these stilled actions attain a newfound significance.

KEY FACTS

Michaël Borremans began painting at the age of 33, having previously taught drawing in an art school for many years.

A major touring exhibition, 'Michaël Borremans: As sweet as it gets', launched at the Palais des Beaux Arts, Brussels, in 2014 before touring to Tel Aviv Museum of Art and Dallas Museum of Art. The show featured 100 paintings spanning two decades.

KEY WORKS

The Bodies 3, 2005, Zeno X Gallery, Antwerp, Belgium
The Devil's Dress, 2011, Dallas Museum of Art, Dallas, USA
The Angel, 2013, Zeno X Gallery, Antwerp, Belgium

URS FISCHER
BORN 1973, ZÜRICH, SWITZERLAND

Lives and works in New York, USA

Urs Fischer employs ephemeral materials and processes to explore issues of transience and loss. His works often play out across time, diminishing slowly and gently with each passing day. Fischer considers that 'decay is natural order and everything that is natural order is per se beautiful'. During the late 1990s, Fischer began experimenting with the sculptural potential of food. *Rotten Foundation* (1998) features a brick-and-mortar structure built atop a heap of decaying fruit and vegetables. To make *Bread House* (2004–5), he used loaves of sourdough to build a Swiss chalet, exposing the structure to the elements to degrade.

Fischer began to make sculptures out of candle wax in 2001. These slow-burn figurative sculptures have become increasingly elaborate and majestic over time. For his contribution to the 54th Venice Biennale in 2011, Fischer made a detailed wax copy of Giambologna's Late Renaissance work *The Rape of the Sabine Women* (1579–83), leaving it to melt and drip slowly to monstrous effect. This work not only touches on human frailty but also challenges the uniqueness of an art object. With digital developments in 3D scanning and printing, Fischer can reproduce these intricate wax sculptures with ease.

Perhaps Fischer's most audacious act was to employ professional contractors to excavate the floor of Gavin Brown's Enterprise, a commercial gallery space in New York. Titled *You* (2007), this work came with its own safety warning. Visitors teetered around the edge of this eight-foot-deep hole. What was formerly a pristine 'white cube' space had become a gaping chasm. The power of *You* emerged from a process of subtraction. The gallery space was less than it was, emptier than empty. Yet it became a receptacle for new ideas concerning cycles of regeneration.

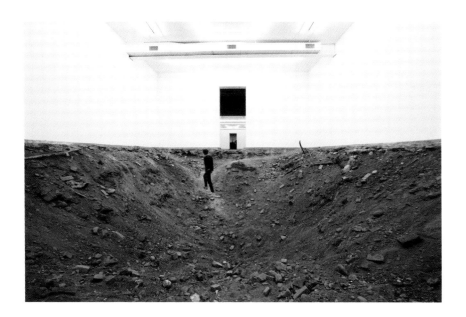

Urs Fischer
You, 2007
Excavation, gallery space
Dimensions variable

Fischer's decision to dig up the floor of a commercial gallery space adds to a long history of artists who have undertaken radical gestures on a massive scale. During the 1960s and 1970s, Michael Heizer and Robert Smithson undertook major excavation work to create their ambitious earth works. Fischer's work also recalls Gordon Matta-Clark's bold architectural interventions of the 1970s.

KEY FACTS

Urs Fischer studied Photography at the Schule für Gestaltung, Zürich. He supported his studies by working as a bouncer in the city's nightclubs.

In 2013, Fischer was the first living artist to be invited to make a solo exhibition at the Palazzo Grassi in Venice. Curated by Caroline Bourgeois, the show featured a recreation of his studio.

KEY WORKS

Untitled, 2000, Museum of Modern Art, New York, USA
Untitled, 2011, Venice Biennale, Venice, Italy

RONI HORN
BORN 1955, NEW YORK, USA

Lives and works in New York, USA

At the heart of Roni Horn's work lies an interest in transformation. Her art connects changing light and weather conditions with our own fluctuating perceptions and identities. Using a range of media including sculpture, installation, drawing and photography, Horn evokes natural forces such as the gradational effects of the weather on human skin and the restless ebb and flow of a river. Since 1975, Horn has made frequent visits to Iceland: 'I come here to place myself in the world. Iceland is a verb and its action is to center.' Spending time in this dramatic landscape has made a lasting impact on Horn's art. Her evocative and poetic works crave natural light and prompt slow contemplation.

Since the mid-1990s, Horn has produced a series of cast glass sculptures. Given the sheer quantity of molten glass needed to create these elegant forms, it can take several months for each sculpture to cure. The sides of each form bear the translucent texture of their original moulds. However, the top surface is fire polished to create a seamless glossy surface, like a still pool. This reflective meniscus captures everything in its orbit: peering figures, architectural features and infinite gradations of natural light. Although Horn's cast glass sculptures are rock solid and extremely heavy, the allusion to water cannot be ignored. Horn has described water as 'a form of perpetual relation, not so much a substance but a thing whose identity is based on its relation to other things. Most of what you're looking at when you look at water is light reflection.' Like water, Horn's glass sculptures reject fixed positions. They hover between solid and liquid, lightness and weight, stillness and movement. Binary positions are questioned, opening space for new possibilities.

Roni Horn
Water Double, v. 1,
2013–15
Solid cast glass with as-cast surfaces, with oculus, two parts, unique
Height, each 132.1 cm (52 in.); diameter, each 134–42 cm (53–6 in.) (tapered); weight, each 4,524 kg (10,200 lb)

Horn is very attentive to the surface of her sculptures, which flicker and glisten like precious jewels or blocks of ice. This installation comprises two cast glass forms: one blue, the other colourless. Horn has expressed an interest in ideas surrounding the double. By presenting two forms in relation to one another, she establishes a dialogue between similarity and difference, attachment and independence.

KEY FACTS

In 1993, Roni Horn gave Felix Gonzalez-Torres a square of
gold foil to mark their friendship and to acknowledge his
verbal endorsement of her work *Gold Field* (1980–2). In 1993,
Gonzalez-Torres referenced Horn in *'Untitled' (Placebo -
Landscape – for Roni)* (1993). This work comprises an endless
spill of sweets wrapped in gold cellophane.

In 2009 a major exhibition of Horn's work launched at the
Whitney Museum of American Art and toured to the Museum of
Contemporary Art, Chicago, and Fondation Beyeler, Basel-Riehen.

KEY WORKS

Still Water (The River Thames, For Example), 1999, Museum of
Modern Art, New York, USA
Pink Tons, 2009, Tate, London, UK

DO HO SUH
BORN 1962, SEOUL, SOUTH KOREA
Lives and works in New York, USA, London, UK, and Seoul, South Korea

The son of a major Korean artist, Suh enjoyed the freedom of forging his own path. He moved to New York City in 1991 and has since lived in many different places and spends much of his time travelling on aeroplanes and trains. He takes a sketchbook with him wherever he goes and takes inspiration from the efficient architecture of travel and the process of moving across place and time.

Suh works across media. However, at the heart of his work lies an interest in the question of what constitutes home. He is perhaps best known for his articulation of domestic spaces using soft-coloured silk or polyester fabrics. Suh has returned to this series repeatedly since the mid-1990s, focusing particularly on the different buildings in which he has lived. To make these works, Suh takes precise scale measurements, documenting everything from windows and doors to light switches, toilets and doorknobs. He then stitches each section by hand, using Korean sewing techniques gleaned from observing his mother at work.

Once installed, Suh's soft architecture assumes a ghostly appearance. Shimmering in the light, these ethereal structures invite us in and prompt us to consider our own progress through life. As Suh has explained: 'The spaces I work with have held many other lives before mine and will continue to be inhabited by others. They're very personal to me but they're a device to evoke emotion, memory and sensation.' Suh pays particular attention to zones of transition and passage such as doorways, stairwells and corridors. The inherent portability of the work is equally important: it can be packed up neatly and carried easily from place to place. For Suh, art and life are inherently nimble and nomadic.

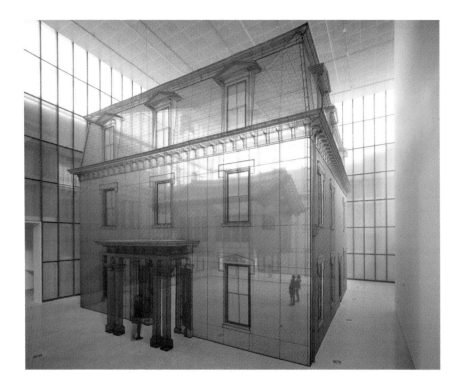

Do Ho Suh
Home within Home within
Home within Home within
Home, 2013
Polyester fabric, metal
frame
15.3 x 12.8 x 13 m
(50 ft 2⅜ in. x 42 ft 1⅛ in.
x 42 ft 6¾ in.)

**The grand outer
building in this life-size
installation represents
the Rhode Island
townhouse where Suh
lived when he first arrived
in America. Hovering
inside is a representation
of the traditional Korean
house in which the artist
grew up. This encasement
raises questions: is the
inner home trapped or
embraced?**

KEY FACTS

Do Ho Suh has drawn inspiration from Felix Gonzalez-Torres's candy
stack works, particularly how they flow in and out of existence. He
also admires Rachel Whiteread's casts of interior space. However,
he considers his own investigations to represent 'a more Eastern
thought process'.

Another important area of enquiry for Suh is the relationship
between individual and collective identities. *Some/One* (2005)
comprises thousands of military identity tags stitched together
to create one metal jacket.

KEY WORKS

Some/One, 2005, Whitney Museum of American Art, New York, USA
348 West 22nd Street, 2011–15, LACMA, Los Angeles, USA

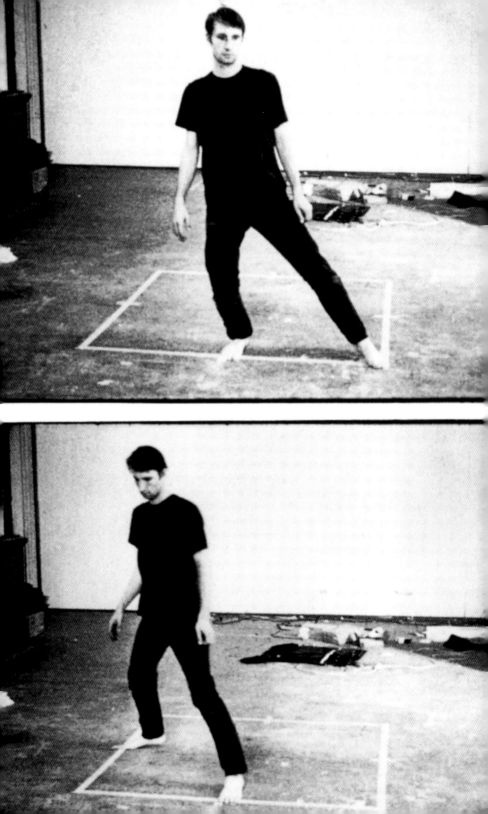

WHAT DO ARTISTS DO ALL DAY?

-

**Being an artist has to do with a way of life,
because you can choose what to do every day**

-

Bruce Nauman, c.1970

Around 1967, the American artist Bruce Nauman undertook a series of actions in his studio. One short film captures him walking in an exaggerated manner around the perimeter of a square taped to the floor. In another, he points his bare toes to each corner of the square, guided by the rhythmic pulse of a metronome.

-

Nauman used deceptively simple (and seemingly daft) gestures to open up new possibilities for artists. He positioned art as a live form played out in space and time and driven by the artist's actions and decisions

-

Artists don't have to stick to one chosen medium and they don't need any specific training. It simply depends on what an artist feels like doing at a given moment, because in Nauman's words, 'you can choose what to do every day'.

This chapter explores some of the roles available to artists working today. It considers how and why artists have stepped away from traditional techniques and materials, choosing instead to assume a dynamic range of performed identities, from actor and stage manager to media celebrity and secret agent.

Before we start, it is important to acknowledge that, for many artists, much of their time is spent managing the demands of their laptop and smartphone, just like the rest of us! Artists often move to live and work in established art centres where there is an infrastructure of opportunities and support, or locate themselves nearby so that they can access such centres when required. Despite attempts to decentralize and diversify the art world, art capitals such as New York, London and Berlin remain very influential, and the trajectories of artists' lives are intriguingly consistent. As the artist Urs Fischer observed in 2020: 'The art world is one of the most conservative places that I know, in a way. What you should and shouldn't do is very mapped out. Most people run along the same paths, all the while thinking they're very free.'

THE PRODUCER

There is a substantial recent history of artists operating as curators. Intense research and enquiry underpin the work of the Polish-born London-based artist Goshka Maçuga. She has explained: 'The process of learning and the accumulation of information and

Bruce Nauman
*Dance or Exercise on the
Perimeter of a Square
(Square Dance)*, 1967–8
16mm film transferred to
video, black and white,
sound, 8 minutes
24 seconds
MACBA Collection,
MACBA Foundation,
Barcelona

This influential film
documents Nauman's
passage around a square
of floor tape. The
relentless tick of the
metronome dictates the
speed of his sequential
toe-tapping of each
corner. Reflecting
on a simple square,
Nauman stages a creative
challenge to Minimalism,
proposing an expansion
of its principles to include
performance and time.

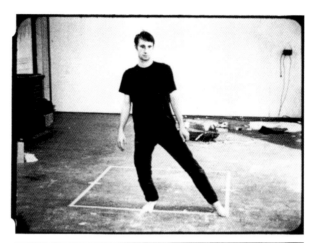

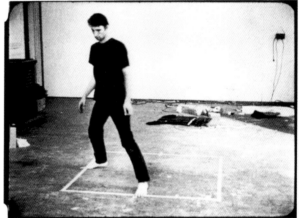

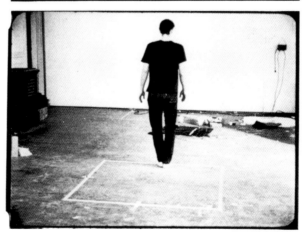

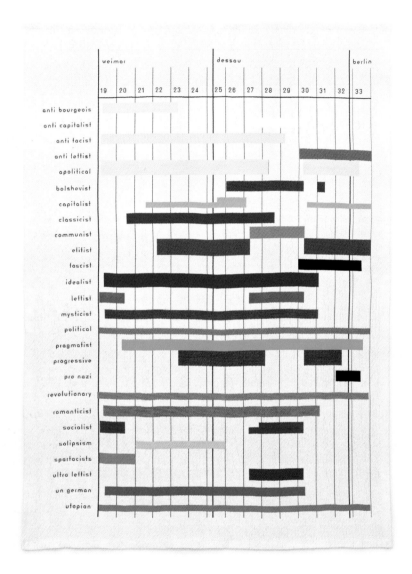

Goshka Maçuga
1919/1933, 2019
Tapestry, edition of
5 + 1 AP
2.9 x 2.1 m
(9 ft 6¼ in. x 6 ft 9⅛ in.)

This tapestry reveals Maçuga's curatorial and research-based methods. Using a simple diagram, she sets out the different ideological positions informing the Bauhaus – the German art school that operated in Weimar,

Dessau and Berlin between 1919 and 1933. The Bauhaus is renowned for its singular Modernist vision of streamlined art and design. Maçuga's tapestry reveals a more complex set of circumstances.

Xu Zhen
In Just a Blink of an Eye,
2005
Performance

**This installation features
four people who appear
frozen mid-fall. The
work was first shown in
China during a period of
economic uncertainty
which had caused
precarious conditions
for Chinese factory
workers. Xu often invites
people from migrant
communities to perform
the work, thus enabling
further reflection on
human vulnerability
in the face of powerful
global forces.**

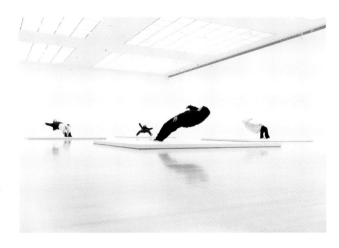

knowledge is the main focus of my work, before the actual process of making.' Maçuga often responds to an exhibition opportunity by spending months scrutinizing a particular context, delving into archives like a cultural archaeologist. She presents her findings in intriguing ways, often combining her own work with other objects to unsettle established histories. Her recent tapestry works are panoramic in scope. They interweave historical content and fresh thinking.

Contemporary artists have also operated as stage managers, overseeing productions from behind the scenes rather than taking centre stage. Anne Imhof conceives and delivers complex, endurance-based scenarios that are performed by other artists, dancers and musicians. The Shanghai-based artist Xu Zhen has also produced performance-based art works undertaken by others. Xu enjoys working collaboratively, commenting that 'it is much more efficient to work as a team than to work independently ... my job is mainly to set the briefs.' *In Just a Blink of an Eye* (2005) is one of Xu's most famous works. The piece employs four people to freeze in a precarious mid-fall moment. Seemingly defying the laws of gravity, these static individuals stare blankly into space, avoiding interaction with the audience. This tightly orchestrated scene conveys a strong theatrical sensibility, coupled with a sense of humour and impish trickery.

THE MAIN CHARACTER

With the greatest of respect, various artists working today could be described as having 'Main Character Syndrome'. They occupy

their work front and centre. Their lives provide the content and their bodies provide the material.

The presence of the artist can give a work a sense of authenticity, directness and truth

This is evidenced in the work of Njideka Akunyili Crosby, who often includes herself in her painted scenarios.

It is always necessary to dig beneath the surface to understand the motivations behind an artist's decision to put themselves in the frame. Antony Gormley has achieved international recognition for sculptures, installations and site-specific works that feature casts of his own body. The ambitious installation *Another Place* (2005) comprises 100 iron figures installed along an extensive stretch of beach. At high tide, the figures become partially or fully submerged by the waves. It is important to stress that the figures in Gormley's work are not intended as self-portraits. Instead, he considers them to operate as stand-ins for a universal human experience. As Gormley has explained: 'I am trying to make work that is reflective and is encouraging of reflection.'

The surfaces of Grayson Perry's ceramic coil pots are emblazoned with memories, personal reflections and social commentary. He also makes prints, tapestries, films and performances, each format offering a further opportunity to engage. Perry is equally well known for appearing as his female alter ego, Claire, dressed in flamboyant costumes. He has also gained considerable attention as a media personality and commentator. He has written books, curated exhibitions, given lectures and made television programmes, each driven by his views on a given topic, be it the art world, identity, class, or Covid-19 lockdowns.

Antony Gormley
Another Place, 1997
Cast iron, 100 elements,
each 189 x 53 x 29 cm
(74½ x 20⅞ x 11½ in.)

Since 2005, *Another Place* has occupied a 3 km stretch of sand at Crosby, UK. The figures gaze out across the water. The artist has explained: 'The idea was to test time and tide, stillness and movement, and somehow engage with the daily life of the beach.'

Grayson Perry
Map of Nowhere, 2008
Etching from five plates
on one sheet
Edition of 68 plus 10 APs
153 x 113 cm
(60¼ x 44½ in.)

Map of Nowhere takes direct inspiration from the medieval *mappa mundi* by Gervase of Ebstorf in which Jesus presides over the world. Similarly encyclopaedic in scope, Perry's version presents himself in the leading role. His intricate etching interweaves personal motivations and perspectives with wider social commentary and satire. Doubt occupies the very centre of Perry's world.

Although operating in very different ways, both Perry and Gormley make art that is widely understood by a broad audience. Incorporating aspects of themselves into their work aids accessibility and relatability.

THE VISIONARY

The German artist Joseph Beuys once famously stated that 'every human being is an artist'. Wary of special training and qualifications, he advocated that we should all look deep within ourselves to find points of connection with nature and society. His poetic art works emerged from shamanistic and ritualistic actions. In 1965, he wrapped his head in honey and gold leaf and carried a dead hare around a gallery, whispering art teachings into its ear. On another occasion he enfolded himself in a felt blanket and cohabited with a live coyote in a locked gallery for three days; the objective was to build a peaceful connection with this predatory animal. Despite his assertion that anyone could be an artist, Beuys set in motion the idea of the artist as a mystical, visionary type.

Skip forward in time to the work of the Serbian performance artist Marina Abramović. Since the 1970s, Abramović has engaged in extreme and dangerous actions to push her body to the limits, usually performing in front of a live audience. In 2010, she

Marina Abramović
The Artist is Present, 2010
Performance
3 months
Museum of Modern Art,
New York

This performance was accompanied by a small plaque instructing: 'Sit silently with the artist for the duration of your choosing.' 1,500 visitors reached the front of the queue. Some found the experience deeply moving. One man endured a full seven-hour stare-athon. A feature-length documentary about the exhibition was released in 2012.

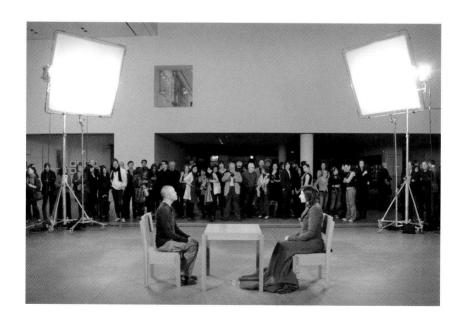

Juliana Huxtable
Lil' Marvel, 2015
Colour inkjet print
101.6 x 76.2 cm
(40 x 30 in.)

Vogue magazine once
described how Huxtable's
photographs 'blend
the visual languages
of comic books and
hip-hop in a way that
looks like an Internet
meme made by aliens'.
This work is a prime
example of Huxtable's
dynamic approach to
self-portraiture. She has
blended photography and
digital technologies to
create a mythological and
fantastical representation
of herself.

undertook a performance at the Museum of Modern Art in New
York. Titled *The Artist is Present*, the work featured a table and two
chairs. Wearing a long dress, Abramović occupied one of the chairs
and invited visitors to occupy the other to engage in a head-to-
head stare. Over the course of almost three months, 750,000
people joined the queue to lock eyes with the artist. Some people
broke down in tears, overwhelmed by the intensity of Abramović's
presence. Others felt that the performance crossed into the realm
of celebrity adulation.

 The notion of the artist as a cult figure or visionary remains
prevalent across contemporary practice. It is evident in the work
of a wide range of artists, including Zadie Xa and Juliana Huxtable.
Huxtable's unique approach to self-portraiture involves her striking
powerful poses in fantastical settings. She takes her inspiration from
a variety of sources, including kitsch Christian posters and science

Cindy Sherman
Untitled, 2019
Dye sublimation
metal print
2.3 x 2.7m
(7 ft 7 in. x 8 ft 11¼ in.)

Although Sherman's photographic practice spans five decades, she remains an acute and canny observer of contemporary life and culture. Her recent works reflect changing definitions of gender, and she has expanded her lexicon to include non-binary identities. Sherman has also embraced digital technologies to further intensify her work.

fiction. Reflecting her experiences as a transgender African American woman, Huxtable uses photography and digital technologies to enhance her assertive visions of intersectionality. She creates her own myths. Everything is possible and difference is powerful.

THE CHAMELEON

Contemporary artists have assumed many different costumes, names and identities to break new ground. Check out the work of Hetain Patel, who has used superhero costumes and henna tattoos to enhance his performance-based practice. Cindy Sherman appears everywhere and yet nowhere in her work. Since the 1970s, she has developed an extensive photographic practice in which she performs each of her fictional characters, yet reveals little, if anything, about herself. She has embodied an extraordinary range of individuals: clowns, the Virgin Mary, victims of crime, Renaissance heroines and B movie stars. In more recent work she has traced the processes of ageing through a sensitive body of work exploring the identities of older women. Sherman prefers to work alone, assuming her characters quietly, attending to all the details. Her practice is not self-portraiture. Her work offers an extensive meditation on the ways in which people, and particularly women, get typecast.

The creative potential of dressing up can also be discerned in the work of the South African artist Zanele Muholi. In 2012, Muholi embarked on a major series of black-and-white photographs titled 'Somnyama Ngonyama', or 'Hail the Dark Lioness'. The series features 365 images, one for each day of the year, to comment on the continual discrimination experienced by black people. Each image casts Muholi as a different character, sometimes a figure from history and at other times a person known to the artist. Commonplace domestic objects are used in innovative ways to create surprisingly stately costumes. Muholi stares back at the camera with a defiant gaze, giving dignity and strength to each character.

Hiding in plain sight is a clear artistic strategy that can lead to innovative work. Perhaps the most extreme example of a secretive artist is the street artist and political activist Banksy, who maintains a tight seal on his identity. He works undercover, leaving examples of his spray-can art in unassuming public spaces, ready to be discovered. Who is he and why is he so private? The thrill of the chase appears to add to the excitement of the work. Artists certainly operate in a range of slippery ways to keep us on our toes.

Zanele Muholi
*Xiniwe at Cassilhaus,
North Carolina,* 2016
Giclée print on paper
80 x 55.6 cm
(31½ x 21⅞ in.)

Muholi employs a host
of familiar objects to
create awe-inspiring
costumes that reveal
narratives of otherness
and belonging. To make
this work, Muholi
utilized a couple of travel
pillows, turning them
the other way round to
create an elaborate neck
decoration.

KEY IDEAS

Artists today frequently change direction, media and genre to
suit their objectives.

Artists often assume the role of a curator or producer to deliver
complex projects and performances.

Many artists occupy their work in very direct ways, often through
performance or radical approaches to self-portraiture.

Assuming different identities enables artists to reflect on issues
concerning equality, inclusion and representation.

KEY ARTISTS

Monster Chetwynd | Rodney Graham | James Lee Byars |
David Hammons | Mariko Mori | Pipilotti Rist | Tino Sehgal |
Tai Shani | Gillian Wearing | Zhang Huan

KEY ACTIVITIES

The next time you visit an exhibition, see if you can spot any
of the character types listed above. You might also be able to
identify some additional roles!

Follow your favourite artists on social media to find out what
they are working on and their current interests and motivations.

BANKSY

It is hard to think of an artist more camera shy than Banksy. Although many people have their suspicions, this infamous street artist has yet to reveal his identity. His art springs up in unassuming places: down back streets and alleyways, on the side of buildings, roundabouts and bridges. Banksy's art appears out of the blue. His trademark stencilling technique enables a rapid spray-can application ahead of an equally hasty getaway. However, this is not a random scattergun approach. Banksy's art expresses a clear social and political conscience and an acute understanding of the power of site and context. Works tend to appear in particular places in response to specific events, conflicts and debates. His figurative imagery often focuses on the impact of major events and decisions on ordinary lives, particularly children and young people. In 2008, for example, a flurry of poignant works appeared in New Orleans on buildings damaged by Hurricane Katrina.

Banksy's street art is often warmly received by its host communities; however, it is vulnerable to theft, damage or removal by the authorities. He also produces prints and original works which are sold through more conventional channels. On 5 October 2018, a rare acrylic on canvas version of his iconic image *Girl with Balloon* came up for auction at Sotheby's in London. Just seconds after the work had sold for £1 million, an alarm sounded and the canvas descended through the jaws of a shredder incorporated into the picture frame. A collective gasp rippled across the packed auction room and the work was quickly removed from display. In a released statement, Sotheby's claimed that 'Banksy didn't destroy an artwork in the auction, he created one.' This 'new' work was authenticated by the artist and titled *Love is in the Bin* (2018). After several days of negotiation, the purchaser agreed to proceed with the sale price. On 14 October 2021, the work returned to auction, this time fetching £18.5 million.

KEY FACTS

Banksy's art first started to appear around Bristol, UK, in the early 1990s. He was closely connected to Bristol's underground scene of musicians and artists.

Banksy
Girl with Balloon,
shredded just after its sale
at a Sotheby's auction in
2018. Retitled *Love is in
the Bin*, 2006/2018
Aerosol paint, acrylic
paint, canvas, board
101 x 78 x 18 cm
(39⅞ x 30¾ x 7⅛ in.)
Staatsgalerie, Stuttgart

**Banksy claims to have
given the work to a friend
in 2006, building the
shredder into the frame
at the time so that it
could be activated in
the event of an auction.
Banksy has also stated
that the mechanism
failed during the
incident, jamming at the
halfway point. He had
intended for the entire
work to be shredded.**

Banksy exhibits his work regularly. A major exhibition titled
'Banksy versus Bristol Museum' took place at Bristol Museum &
Art Gallery in 2009 and featured over 100 works.

KEY WORKS

Love is in the Air (Flower Thrower), 2003, Bethlehem, Palestine
Basquiat being 'stopped-and-frisked' outside the Barbican Centre,
2017, Barbican Centre, London, UK

NJIDEKA AKUNYILI CROSBY
BORN 1983, ENUGU, NIGERIA

Lives and works in Los Angeles, USA

Njideka Akunyili Crosby moved to the States when she was sixteen years old to pursue her education. She 'felt an urgency to tell my story as a Nigerian in diaspora' and painting provided a perfect platform to express multiple perspectives and identities: 'I wanted to root my work in a transcultural space, that weird, buzzing in-between space, a kind of no-man's land.' Akunyili Crosby works on a large scale, often on heavy paper. She depicts individuals and groups of figures who occupy domestic spaces and engage in ordinary activities such as enjoying a quiet moment or meeting family and friends. Akunyili Crosby establishes tenderness in her paintings, yet this is always a respectful and unobtrusive kind of intimacy. Her figures avoid eye contact with the viewer. Narratives are suggested yet never fully explained.

Collage and photo transfer techniques play an important role in Akunyili Crosby's paintings. She builds her work slowly, using intricate layers of imagery sourced from frequent trips to Nigeria. Reproductions of pop icons, lawyers, models and political dictators rub shoulders to create densely patterned zones which could articulate any number of surfaces from fabric to furniture. There is an additional layer of resonance in Akunyili Crosby's frequent reference to western art history. She has cited the influence of a broad range of artists, including Chris Ofili, Édouard Vuillard and Diego Velázquez. Her interest in still life painting is evident in her close attention to every object and surface texture. Equally compelling is her frequent incorporation of bold planes of colour – a clear nod to the history of abstract art. Akunyili Crosby's paintings fuse past and present, personal and political, Nigerian and American references to create an alluring and poignant in-between space. 'My journey has created a character who doesn't really fit into any box.'

Njideka Akunyili Crosby
I Still Face You, 2015
Acrylic, charcoal, coloured pencils, collage, oil and transfers on paper
2.1 x 2.7 m
(7 ft x 8 ft 9 in.)
Los Angeles County Museum of Art,
Los Angeles

This painting imagines the artist introducing her Caucasian American husband to her family for the first time. Standing next to her husband, Akunyili Crosby assumes a classical pose and wears an elegant yellow dress. Her skills as a painter are evidenced in her handling of a wide range of surfaces. The use of collage and photo transfer helps to unify the picture plane.

KEY FACTS

In 2019 Njideka Akunyili Crosby was awarded an honorary
 doctorate from Swarthmore College, Pennsylvania.
Akunyili Crosby has made several works for public spaces, including
 Before Now After (Mama, Mummy and Mamma), (2015), which was
 sited outside the Whitney Museum of American Art, New York, as
 part of the *Outside The Box* programme in 2016.
Akunyili Crosby's work is represented in many significant
 collections across the world including Tate, London, and Zeitz
 Museum of Contemporary Art Africa, Cape Town.

KEY WORKS

And We Begin to Let Go, 2013, Museum of Modern Art, New York,
 USA
Portals, 2016, Whitney Museum of American Art, New York, USA

ANNE IMHOF
BORN 1978, GIESSEN, GERMANY

Lives and works in Berlin,Germany, and New York, USA

At the opening of the 2017 Venice Biennale, one name was on
everybody's lips: Anne Imhof. Her performance work *Faust* (2017)
transformed the German Pavilion into an electrifying and tense
environment. The piece received huge critical attention and won the
prestigious Golden Lion prize for Best National Pavilion. Visitors to
the pavilion were greeted by a pack of brutish Doberman dogs, kept
in metal cages. The space inside the pavilion was equally unnerving.
A false glass floor and several divisions and raised platforms enabled
a range of viewpoints and perspectives. A cast of surly, slender youths
dressed in dark-coloured sportswear occupied the space. They
jumped down from ledges and hung out in packs. They screamed,
growled, writhed and cavorted on the floors. Some appeared to
dance and sing to an intense soundtrack, while others engaged

in sexualized contact. The audience looked on, bemused and disconcerted. At times the performers took part in an unprovoked face-off with an unsuspecting visitor: unblinking, unsmiling, unnerving.

Anne Imhof's confrontational works fuse performance, choreography, music, sculpture and installation. The delivery of her work involves recruiting a team of dancers, poets, models, musicians and friends. They follow a preconceived score and respond to her instructions via text message. Each performance, which can last around four or five hours, is driven by careful planning and improvisation. Imhof reflects: 'It's about accidents that happen, the ability to trust. The more that is accidental, the more precise the whole thing gets.' Despite the many methods and disciplines informing Imhof's work, she considers painting to be a strong source of reference. Using architecture as her frame, she orchestrates bodies in space to create powerful compositions expressing strong human emotions. Perhaps a surprising influence is the Irish-British painter Francis Bacon. His paintings of humans and animals writhing among rectilinear platforms and framing devices provide a compelling precedent.

Anne Imhof
Faust, 2017
Performance

Imhof's works often bear simple, one-word titles that can be interpreted in a variety of ways. *Faust* is the German word for fist, but it is also the name of the lead character in Goethe's tragic play, in which Faust sells his soul to the devil in exchange for earthly gratification.

KEY FACTS

Anne Imhof made music and worked as a bouncer before deciding to study art at the Städelschule in Frankfurt (2008–12).

In 2017, Galerie Buchholz released Imhof's debut single, *Brand New Gods*, in an edition of 300.

KEY WORKS

Angst, 2016
Sex, 2019–21

HETAIN PATEL
BORN 1980, BOLTON, UK

Lives and works in London, UK

Hetain Patel's practice takes many forms, including performance, film, photography and sculpture. His works are usually presented in galleries and theatres. However, he has also given talks and used YouTube to engage with a wider audience. Patel is a consummate performer. Using processes of imitation, he combines personal memories with popular culture references to create poignant reflections on identity and belonging. His objective is to find points of connection: 'I'm interested in bridge building.'

Patel grew up in a working-class British Gujarati family and recalls experiencing racial discrimination as a child. Watching kung fu and superhero movies provided a source of empowerment and escapism. He discovered another world in which difference was a source of strength. Patel was particularly drawn to Spider-Man's masked persona: 'For me, it's not about having super powers but more about the joy of being able to be defined by your actions and not the outer signs that define you, such as gender, race or age.' To make *The Jump* (2015), Patel invited seventeen members of his family to his grandmother's house, requesting they wear their best 'wedding' outfits for the occasion. Wearing a special handmade Spider-Man costume, Patel launched himself from the sofa. His actions reflect his childhood quest for freedom and acceptance but also acknowledge the epic leap taken by his relatives when migrating to the United Kingdom.

Patel often works collaboratively and he has enjoyed a particularly fruitful partnership with his father. In 2013 they worked together to create *Fiesta Transformer*. Unlike the high-tech, streamlined car robots in the 1980s American cartoon series, the Patel version transforms a vehicle associated with British working-class culture into a submissive squatting figure. Patel has explained how 'this posture is a recurring image in my work and forges a link between the lower classes in India and my immigrant family in the UK, both of whom sit comfortably this way'.

Hetain Patel
The Jump, 2015
2 channel video
installation, HD video
with sound
6 minutes 32 seconds

**Patel collaborated with
a specialist film crew
to make this work. The
footage was slowed to a
hundredth of real time,
transforming a fleeting
moment into six and
a half minutes of high
drama. Patel's descent
from the sofa to an
ornate rug assumes epic
significance, aided by a
dramatic score composed
by Amy May. A second
screen shows the action
from a different angle.**

KEY FACTS

In 2019, Hetain Patel won the 12th Jarman Award. This prize is
dedicated to the memory of Derek Jarman and supports artist
filmmakers based in the United Kingdom.

Patel's work featured in 'British Art Show 9' (2021–2). This major
touring exhibition of contemporary British art is staged every
five years.

KEY WORKS

Fiesta Transformer, 2013
Don't Look at the Finger, 2017, Tate, London, UK

ZADIE XA
BORN 1983, VANCOUVER, CANADA

Lives and works in London, UK

Canadian born and of Korean heritage, Zadie Xa explores issues of identity and diaspora though hybrid works which incorporate performance, film and textiles. Xa has undertaken extensive research into Korean folklore and shamanism. She is intrigued by the fact that many Korean shamans were female. Cast out from patriarchal society, they created inclusive communities in remote areas and used magic, ritual and trance to inhabit a space between the living and the dead. Xa has explained: 'I'm really fascinated with how the shaman is a figure in the in-between space. Coming from a diasporic position, one feels constantly in between.'

Xa collaborates with musicians, dancers and artists to stage shamanistic performances. She considers this process to be akin to 'dancing with ghosts, … being in company with your ancestors through reenactment.' Her female protagonists wear special costumes and animalistic masks, parading in public to the hypnotic pulse of the drum. These performances recall traditional Korean masked dances, but they also seek a central position for diverse communities within civic space. For Xa, clothing plays an important role in shape shifting and transformation: 'Clothing allows you to change who you are; it mediates the person that you, on that particular day, wish to present to the world.' Xa has used traditional Korean sewing methods to create ornate capes, which she has worn during her performances. Reminiscent of magic and superheroes, capes also enable strong freedom of movement. Xa adorns her capes with symbols sourced from eastern and western cultures, challenging stereotypes and reflecting her diasporic experience.

Zadie Xa
SVN Stacks/Moon Marauder, 2015
Synthetic hair on machine-stitched and hand-sewn fabric
130 x 165 cm
(51¼ x 65 in.)
Arts Council Collection, Southbank Centre, London

Xa used traditional Korean stitching techniques to appliqué a range of cultural symbols onto this sumptuous cape. Frequent references to the letter 'G' refer to Ganggangsulae, a traditional Korean fertility ritual performed by women beneath a harvest moon. Xa wore this cape in her 2016 film *Mood Rings, Crystals and Opal Coloured Stones.*

KEY FACTS

Zadie Xa initially trained as a painter but quickly discovered that she needed a wider set of processes to express the layers of content she wished to convey.

Xa's performance for the 58th Venice Biennale in 2019 involved a procession through the outdoor spaces of the Biennale's Giardini. The work referenced the myth of Grandmother Mago, who was said to have created Korea's landscapes through her actions and excretions.

KEY WORKS

Call Waiting, 2018, British Council Collection, UK
Grandmother Mago, 2019, performance at the 58th Venice Biennale, Italy

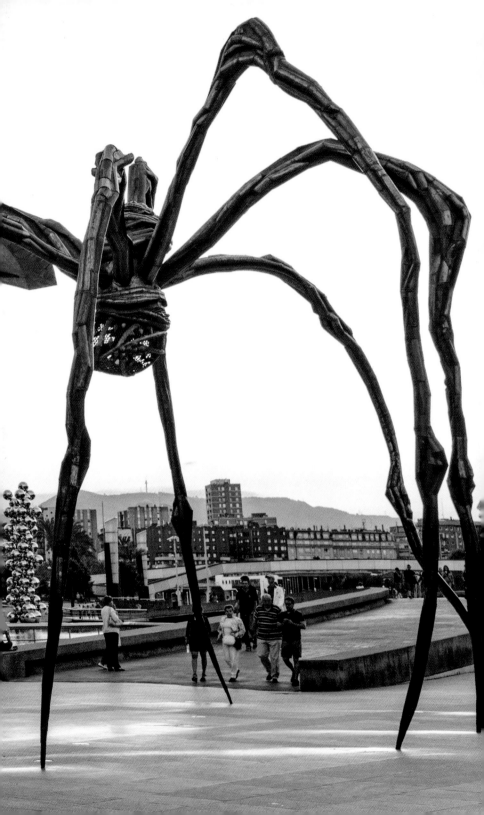

WHY DO ARTISTS
TELL TALES?

-

Tell your own story and
you will be interesting

-

Louise Bourgeois, c.2008

Contemporary art often strays very close to the realm of fiction. There are so many stories to be discovered across a range of media: historical narratives, time travels, diaristic confessions. Why are so many artists intent on telling tales, and how can we untangle fact from fiction? This chapter identifies a wide range of narrative approaches employed by artists and some of the reasons behind this fascination with storytelling.

Painting has long maintained a strong association with storytelling

For centuries, history paintings – large-scale representations of religious or historical narratives – were considered the highest form of art. Exceptional technical skill was needed to convey this ambitious imagery. The ability to reflect moral and virtuous messages was considered the true purpose of art.

Storytelling fell out of fashion during the first half of the twentieth century as many artists strove to streamline their work along Modernist principles. By the end of the century, narrative content had returned with a vengeance, becoming a popular mode of expression. The rise of Postmodernism, with its acceptance of many voices, ideas and perspectives, provided fertile ground for storytelling to flourish. It is no coincidence that many artists turned to time-based media during these years. Film and video can capture even the most complex narratives.

EPIC TALES

Contemporary artists certainly cannot be accused of half measures when it comes to storytelling. Take the American artist Matthew Barney. His five-part feature-length film series *The Cremaster Cycle* (1994–2002) takes the viewer on an intense journey through time and place. This epic work is accompanied by a substantial body of drawings, sculptures, books and photographs: no expense appears to have been spared on its production. The work takes as its starting point the cremaster muscle, which raises and lowers the testicles. People wishing to follow the story may be disappointed: there are just ten spoken phrases across almost seven hours of footage. That said, the outstanding cinematography and the visceral imagery combine to create a thrilling visual spectacle.

The Swedish artist Nathalie Djurberg makes work that is equally cinematic in scope and rich in narrative content. Djurberg uses

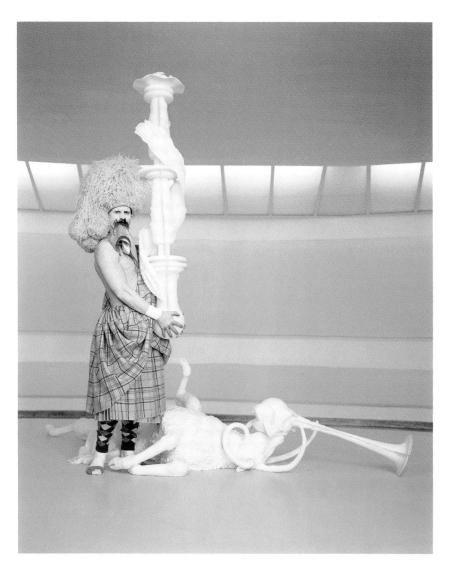

Matthew Barney
Cremaster 3, 2002
Production still,
DVD 2 hours 59 minutes

The third film in
The Cremaster Cycle was
shot on various locations
in New York, including
the Guggenheim
Museum. This stunning
building provided the
backdrop for Barney's
extraordinary visions.

For this disturbing scene,
the artist sported a
peach-coloured kilt and
flamboyant headwear and
spewed an unidentifiable
substance from his
mouth.

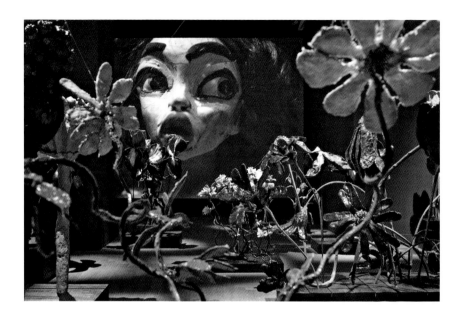

clay animation to realize dark visions of debauched human and animal behaviours. Despite the naive, almost childlike, nature of her imagery, her narratives convey adult themes spanning jealousy and torture, murder and bestiality. Her fairy tales often turn into nightmares. The intensity of her work is heightened through the sinister soundtracks created by the musician and composer Hans Berg – Djurberg's partner and long-term collaborator. Equally compelling is Djurberg's decision to present her animations alongside spooky sculptural assemblages of anthropomorphic flowers, insects and birds.

-

Artists have an uncanny way of appearing to say everything while giving little away

-

The German painter Neo Rauch makes large, epic paintings reminiscent of the grand posturing of history paintings. These works seem authoritative and definitive, but look again and nothing feels certain. We find muscular men and women engaged in a range of actions, yet on closer inspection they appear lost in their own worlds. Ultimately, the experience of looking at Neo Rauch's paintings is akin to that strange moment of vivid dreaming just before waking when anything feels possible.

Nathalie Djurberg &
Hans Berg
The Experiment, 2009
Stop motion animation,
video, music
5 minutes 33 seconds

This work was first shown at the 53rd Venice Biennale in 2009, where it won a Silver Lion prize. It features three animations presented among a sculptural set of looming flowers. The narrative takes the viewer into a prehistoric jungle where individuals engage in hedonistic and depraved behaviours.

Neo Rauch
Handlauf, 2020
Oil on canvas
2.5 x 3 m
(8 ft 2½ in. x 9 ft 10⅛ in.)

Rauch grew up in East Germany and his work is thought to reflect his experiences of growing up behind the Iron Curtain. Many critics have forged a connection between his work and Soviet Realism. Others have suggested the influence of Surrealism. The title of this beguiling scene translates as 'Handrail'.

Telling tales does not have to involve a grand scale, a blockbuster budget, or a whole cast of characters. Sometimes, it is the snatched fragment, the knowing glance, or the fleeting moment that can set in motion a whole chain of suggested narratives. The unnerving paintings of Luc Tuymans, for example, focus on tiny details to suggest much larger histories and traumatic events.

TIME TRAVELS

For a surprising number of artists, the passage of time itself has provided an enduring source of inspiration. In 1999, the Japanese artist On Kawara published a two-volume book titled *One Million Years*. The first volume listed a million years into the past, with the second volume listing one million years into the future, ending with 1,001,092 AD. Many painters including Shahzia Sikander and Lisa Brice have borrowed techniques and compositions from the past to reflect on contemporary issues concerning feminism and representation.

Perhaps the easiest way to take dramatic leaps through space and time is to visit a cinema. It is easy to understand why the movies have provided such an enduring source of inspiration to artists: the epic scale, wide-screen vistas, the endless narrative potential. In 2010, the American artist Christian Marclay created *The Clock* – a remarkable and meticulous homage to the world of cinema. To make this ambitious work, he employed a team of researchers to survey the history of film with the specific task of finding scenes that featured a timepiece. After several years, Marclay had sufficient material to produce a 24-hour sequence of consecutive time-telling clips.

An archiving impulse informed the work of the French artist Christian Boltanski. He gathered found images and personal possessions from a variety of sources, incorporating them into haunting and evocative installations which reflect personal and collective memories. These poignant accumulations evoke dark moments in modern European history and embody Boltanski's own childhood experiences as the son of displaced Jewish immigrants. Despite these specific references, much of the imagery in Boltanski's work stems from other sources, prompting the viewer to question the perceived ability of photography to reveal truths.

Christian Marclay
The Clock, 2010
Single-channel video
installation, 24 hours

The film is synchronized to tell the time, so when the clock strikes noon, it is noon in real life. Although the narrative is in some ways disjointed and fragmented, *The Clock* splices thousands of movies into one coherent rumination on the relationship between actual and cinematic time.

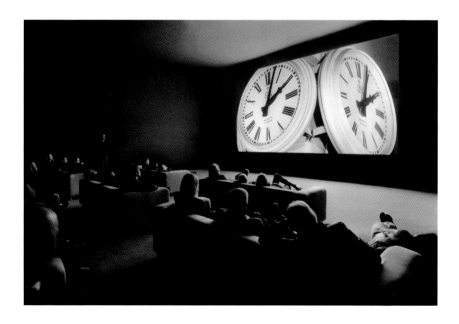

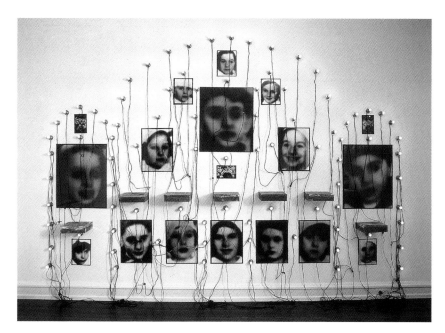

Christian Boltanski
Monument (Odessa),
1989–2003
Fifteen gelatin silver
prints, metal cookie jars,
three colour coupler
prints and lamps
230 x 350 x 21.6 cm
(90⅝ x 137¾ x 8½ in.)

Faces in this work
derive from a 1939
French photograph of
children celebrating
Purim. The altarlike
presentation of lights
and boxes conveys
a sombre, ritualistic
atmosphere. Reference
to Odessa in the title
denotes Boltanski's
Ukrainian heritage.

INTIMATE DETAILS

Why pursue a third-person narrative when the intimate details of one's own life can provide such a rich and accessible source of authentic material? As the French American artist Louise Bourgeois once advised: 'Tell your own story and you will be interesting.' Her deeply personal work, drawing on memories, desires, fears and even gigantic spiders, has provided a huge source of inspiration to subsequent generations of artists. The French artist Sophie Calle has also championed the use of narrative within her work. She has spun many yarns using a range of methods including diaries and various forms of surveillance.

For a while, it seemed impossible to visit a gallery without stumbling across the whispered revelation of some long-held secret or intimate preference. Tracey Emin's autobiographical work appears honest and raw. Through drawings, prints, writings, textile works and sculptural installations, she shares her innermost thoughts. Emin's work often feels fragmentary and snatched, as if produced in the heat of the moment. This impulsive strain adds to the apparent sense of authenticity.

For some artists, photography has provided an excellent tool for capturing fleeting moments and social interactions with intimate

Tracey Emin
Fantastic to Feel Beautiful Again, 1997
Neon
111.76 x 140.02 x 8.26 cm
(44 x 55⅛ x 3¼ in.)
San Francisco Museum of Modern Art

Neon signs have played an important role in Emin's practice since the mid-1990s. Emin uses neon to reveal her innermost thoughts and feelings, usually delivered in her characteristic slanted handwriting. Her choice of this medium most likely stems from her memories of growing up in the British seaside town of Margate, where neon illuminations were commonplace.

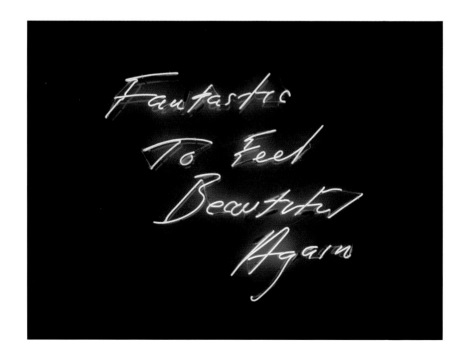

honesty. Check out the work of the American photographer Nan Goldin, who used her camera as a kind of visual diary, capturing her social interactions in 1980s New York City. From drag queens and parties, to personal traumas and the experience of AIDS, Goldin's imagery oozes intimacy and compassion. Her work has provided a huge source of inspiration to subsequent generations of photographers. Take the work of Catherine Opie, for example. The photographic portraits she has made of herself and her friends from the LGBTQIA+ community in Los Angeles are similarly empathic and ennobling. Opie considers herself to be a 'kind of twisted social documentary photographer'. That said, all her images are meticulously crafted and often reference art historical sources.

WHOSE STORY IS IT, ANYWAY?

The Black Lives Matter protests that emerged in the wake of the murder of George Floyd in May 2020 highlighted the conscious and unconscious biases underpinning many aspects of society. Statues were toppled and the discriminatory actions of individuals and institutions were exposed. Art historians intensified their efforts to dislodge the established canons of art, and curators reviewed the diversity of their programmes and collections. Artists, however, had been ahead of the curve for some time.

Artists are untangling historical and contemporary narratives to reveal structural biases and sources of exclusion

Check out the work of Yinka Shonibare. His major installation, *The British Library* (2014), highlights the contribution made by immigrants to British culture.

The American artist Kara Walker works across media but is perhaps best known for her black cut-out silhouettes which forge dramatic dioramas across the gallery space. At first glance, her cartoon-like scenes look innocent and exuberant, but on closer inspection one finds distressing scenes of violence and brutality from the history of American slavery. Walker has commented on her interest in mixing seduction and repulsion: 'I wanted to make work where the viewer wouldn't walk away; he would either giggle nervously, get pulled into history, into fiction, into something totally demeaning and possibly very beautiful.' Walker's recent large-scale drawing *Christ's Entry into Journalism* (2017) is equally seductive in

Catherine Opie
Dyke, 1993
Pigment print
101.6 x 76.2 cm
(40 x 30 in.)

The lighting and damask drapery in this work recall the portraiture of the Northern Renaissance painter Hans Holbein (1497–1543). The traditional lettering of the sitter's tattoo adds to the historical atmosphere. In facing away from the viewer, the sitter maintains dignity and performs a rejection of mainstream heterosexual culture.

Kara Walker
Christ's Entry into
Journalism, 2017
Sumi ink and collage
on paper
3.6 x 4.9 m
(11 ft 8⅛ in. x 16 ft ⅛ in.)
Museum of Modern Art,
New York

Walker chose a biblical
title for this large
drawing. In doing so, she
connects the persecution
and crucifixion of Jesus
with the brutal treatment
of black people. At
the top of the work, a
lynching takes place. The
crowd scene features
an ahistorical cast of
characters including
Frederick Douglass and
Martin Luther King, Jr.

its lyrical use of pencil, ink and collage. The work replaces a linear 'progression' of historical events with a more complex intermingling of past and present. We find historical figures such as Martin Luther King, Jr., alongside riot police, soldiers, parties and a lynching. For Walker, moving forward must include a full acknowledgment of the past.

Jon Key's brightly coloured portraits of himself and other people forge a space for intersectional identities. Key was born and raised in Seale, Alabama, in America's Deep South. From a young age, he became aware that his identity as a queer black man did not fit with the taught norm. Through his paintings, Key explores the four central strands of his identity: 'Southernness, Blackness, Queerness, and Family'. He uses colour symbolically, with green, black, purple and red representing each of his four themes respectively. In recent work, Key has created group portraits of families, not just his blood relations, but also the close friendships and networks he has forged in New York City. In foregrounding his past and present situations, Key has discovered a new sense of freedom: 'I love that I can construct, shift and alter my story. I have full agency and control.'

Jon Key
Chosen Family No.1,
2020
Acrylic on panel
182.8 x 121.9 cm
(72 x 48 in.)

This painting celebrates Key's chosen 'family' of friends that he has nurtured in New York City. Colour is used symbolically, with red representing family, and violet alluding to queerness. The chequerboard patterning of the picture surface stems from Key's training as a graphic designer but also acknowledges his admiration for the work of Gustav Klimt (1862–1918).

KEY IDEAS

Contemporary artists frequently use a range of narrative forms.

Artists have drawn inspiration from various sources including film, fiction, history and political events.

Autobiographical content remains popular, with artists sharing personal details to achieve authenticity.

Storytelling can help to dislodge discriminatory narratives, making space for new perspectives.

KEY ARTISTS

Etel Adnan | Kader Attia | Marlene Dumas | Emilia & Ilya Kabakov | William Kentridge | Shirin Neshat | Philippe Parreno | Laure Prouvost | Paula Rego | Zineb Sedira

KEY ACTIVITIES

Keep a diary to log your encounters with contemporary art. It's a great way to remember what you have seen and can help clarify your responses and ideas.

Read an artist's life story. There are various titles to choose from, including autobiographies by Sophie Calle, Tracey Emin and Grayson Perry.

LISA BRICE
BORN 1968, CAPE TOWN, SOUTH AFRICA

Lives and works in London, UK

Lisa Brice
No Bare Back, After Embah, 2017
Synthetic tempera ('Flashe'), gesso, ink and oil on linen
244 x 198 cm (96⅛ x 78 in.)

Cobalt blue plays an important role in Brice's art. It enables her to explore neon and twilight effects, and also allows her to distance female bodies from traditional modes of representation. Her colour choice also references the 'blue devil' tradition in Trinidadian carnivals, where people smear their entire bodies and faces in blue paint for the purpose of engaging in revelry without being identified.

The paintings of Lisa Brice depict women as strong and self-directed, free from the shackles of art historical representation. Brice has explained how 'historical figuration seems invariably created by white men for an audience of predominantly white men. Sometimes the simple act of repainting an image of a woman previously painted by a man – re-authoring the work as by a woman – can be a potent shift in itself.' Brice's images of women are drawn from a wide variety of sources, including art history, magazines and the internet. She resituates them in new scenarios inspired by her lived experience of South Africa, Trinidad and London. The prevalent use of cobalt blue and bright vermilion adds to the intensity of these powerful scenes. Narratives are implied yet remain open to interpretation. Brice has explained: 'I am drawn to the ambiguity that people and places can hold. Sometimes the compositions of my paintings feel like cinematic outtakes: the moments between directed actions, when the figures are "on their own time", self-involved, performing only for themselves or one another.'

No Bare Back, After Embah (2017) represents a neon-lit bar which Brice frequented with the artist Emheyo 'Embah' Bahabba (1937–2015). The shrieking cat alludes to the black cat in *Olympia* (1863), Édouard Manet's famous painting of a reclining naked woman. Manet is also referenced in the seated figure, who mirrors the pose of the female drinker in *Plum Brandy* (c.1877). The stance of the standing woman derives from a photograph of the Trinidadian rapper Nicki Minaj. Together with the cat, she stares into the foreground at an unspecified source. Meanwhile, the scantily clad figures break all the rules of decorum. They smoke, drink and dance suggestively, flaunting the 'NO BARE BACK' neon signage glowing in the foreground.

KEY FACTS

Lisa Brice arrived in London in 1998 to take up a residency.
 She has also spent time living and working in Trinidad.
Doors, windows and grilles recur throughout Brice's paintings.
 They establish a transitional space between public and private, interior and exterior.
In 2021 *No Bare Back, After Embah* (2017) sold at auction for
 $3.1 million, 91 times Brice's previous record.

KEY WORKS

Between This and That, 2017, private collection, Germany
Untitled, 2019, Tate, London, UK

SOPHIE CALLE
BORN 1953, PARIS, FRANCE

Lives and works in Paris, France

Storytelling lies at the heart of Sophie Calle's practice. Spanning film, photography, performance and text, her work has influenced successive generations of artists. Calle never went to art school and she smarts a little at the idea of being an artist, preferring instead to frame her projects as private games. Calle often assumes the role of a detective. She uses surveillance to trace the lives of others, employing methods that could be considered intrusive and voyeuristic. In 1980, Calle secured a job as a chambermaid in a hotel in Venice. She used her position to track the occupants of each room, photographing their possessions and establishing a written account of their lives. Three years later, Calle found an address book. Before returning it, she photocopied the contents and approached each listed contact, building an account of the owner, which she published in a national newspaper.

Calle has also embraced the role of diarist to assess vulnerable moments in her own life, reflecting on relationship breakdowns and the death of her mother. In 1994, Calle was invited to make an exhibition for the Museum Boijmans Van Beuningen in Rotterdam. She inserted a selection of personal objects into existing display cabinets. Using a special audio guide, *La Visite Guidée*, visitors could listen to Calle recount a story for each object. The guide also featured a soundtrack composed by Laurie Anderson. Calle's witty approach to storytelling deliberately blurs boundaries of truth and fiction. In presenting objects of supposed personal significance among a wider collection of things, she highlights the potential of inanimate objects to suggest layers of meaning and narrative. It is left to the viewer to assess the truthfulness of her engaging yarns.

KEY FACTS

In 1994, Sophie Calle published *True Stories*, a book of images and texts recalling moments from her life. The book has been revised several times to include new tales.

Sophie Calle
Red Shoe, 2000
Iris print on cream
Arche paper
92.1 x 66 cm
(36⅜ x 26 in.)

A single red shoe
represents an episode
from Calle's childhood
when she engaged in
petty shoplifting with
her friend Amélie.
Calle's suspicious mother
told them that she had
notified a police officer
and that he would
monitor the girls going
forward. A pair of red
ladies' shoes was the last
trophy taken by the girls
before they turned their
attention to identifying
the mystery police
officer. Amélie kept the
right shoe and Calle
the left.

Amélie and I were eleven years old. We had a habit of stealing from department stores on Thursday afternoons. We did that for one year. When her mother began to suspect, in order to frighten us she said that a policeman who had spotted us came and reported our activities to her. But because of our age, he was going us a second chance. We would now be followed by him, and if we stopped stealing, he would forget about the past. In the following weeks, we spent most of our time wondering who the policeman hidden among all the people around us was. In our attempts to lose him, we were now too busy to steal. Our last robbery had been a pair of red shoes too big for us to wear. Amélie kept the right shoe, and I kept the left.

Calle represented France at the 52nd Venice Biennale in 2007 with *Take Care of Yourself* (2007). To make this work, Calle invited 100 women to interpret a breakup letter she had received from an ex.

KEY WORKS

The Hotel, 1981, various collections including Tate, London, UK, and Solomon R. Guggenheim Museum, New York, USA

Couldn't Capture Death, 2007, courtesy Paula Cooper Gallery, New York, USA, Fraenkel Gallery, San Francisco, USA, and Galerie Perrotin, Paris, France

YINKA SHONIBARE CBE
BORN 1962, LONDON, UK

Lives and works in London, UK

Yinka Shonibare
The British Library, 2014
6,328 books, Dutch wax
print fabric, gold foil,
software, networked,
world wide web,
table and chairs
Dimensions variable
Tate Gallery, London

The British Library has
been exhibited in a range
of contexts since it was
made, including the
Diaspora Pavilion of the
57th Venice Biennale in
2017. Shonibare created
The American Library in
2018. Made in response
to Donald Trump's anti-
immigration stance, this
installation charts the
contribution made by
immigrants to American
culture.

Yinka Shonibare was born and educated in London but spent his formative years in Nigeria. He considers himself to be a 'post-colonial hybrid' and his art explores and celebrates the diversity and complexity of our globalized world. Shonibare's work spans painting, sculpture, installation, film and photography. He often references moments from art history to reveal stereotypes and fixed positions and to comment on issues of race and class. Since 1994, Shonibare has frequently incorporated Dutch wax printed cotton into his work, enjoying its complex global associations. This brightly coloured patterned fabric, based on Indonesian batik designs, was originally produced in the Netherlands, and sold to African colonies.

The British Library is a major installation featuring 6,328 hardback books presented neatly on shelves. Each book is covered in Dutch wax printed fabric. 2,700 of the books feature a gold-leaf name printed on their spines. The names reference first- or second-generation immigrants who have contributed to British culture, from Hans Holbein and Mary I to Sigmund Freud and Zadie Smith. The spines of the remaining volumes are left unmarked, indicating an unwritten history yet to unfold. Intriguingly, Shonibare also includes the names of individuals who have opposed migration. In doing so, he establishes his library as a space for debate and learning. The library can be used as a research hub, with tablets providing access to a full list of the represented individuals and Shonibare's selection of further reading about immigration. There is also space for visitors to add their own migration stories. This material can also be accessed digitally by visiting http://thebritishlibraryinstallation.com.

KEY FACTS

Yinka Shonibare's first public commission, *Nelson's Ship in a Bottle*, was presented on the Fourth Plinth in Trafalgar Square, London, in 2010.

In 2018 Shonibare was awarded a CBE (Commander of the Most Excellent Order of the British Empire) for his services to art.

KEY WORKS

Diary of a Victorian Dandy, 14:00 Hours, 1998/2012, Victoria & Albert Museum, London, UK

The Crowning, 2007, Arts Council Collection, London, UK

SHAHZIA SIKANDER
BORN 1969, LAHORE, PAKISTAN
Lives and works in New York City, USA

Shahzia Sikander learned the intricate techniques of Persian and
Mughal Indo-Persian manuscript painting at the National College
of Arts in Lahore before continuing her studies in America.
Drawing inspiration from the layered narratives and metaphors
of this ancient art form, she decided to infuse the genre with
contemporary relevance. Her intricate work blends personal
reflections on race, feminism and colonial and post-colonial
histories. Although her work suggests multiple narratives, it rarely
draws conclusions. This spirit of freedom reflects Sikander's own
diasporic experience: 'I began to see my identity as being fluid,
something in flux.'

Sikander started out producing exquisite miniatures using
authentic materials and techniques. However, her practice has
expanded to include sculpture, film and animation. Drawing
provides the thread connecting all her work. She also values a poetic
means of expression: 'Poetry's ability to condense and heighten
an experience with words is an inspirational device. Developing a
parallel process, I usually create a painting as a poem, where its
formal dynamics intersect with emotional and social consciousness.'
Pleasure Pillars (2001) operates as a kind of visual poem. Although
small, this exquisite work packs in a multitude of metaphors and
archetypes to explore female desire and sensuality. A self-portrait
of Sikander occupies the heart of the work. Her delicate features
are surrounded by striped ram's horns, creating a surreal spectacle.
The horns are upheld by two ancient headless statues: Venus
and a South-East Asian celestial dancer. This enchanting scene
is shadowed by the malevolent presence of a fighter jet and a
fantastical winged beast brandishing fire. Even the floral motif in the
foreground is constructed of predatory warplanes. Sikander created
this work around the time of the 2001 terrorist attacks on the
World Trade Center in New York City.

Shahzia Sikander
Pleasure Pillars, 2001
Opaque and transparent
watercolour and tea on
wasli paper
43.2 x 30.5 cm
(17⅛ x 12⅛ in.)
Shahzia Sikander Studio

Sikander often borrows
techniques and skills
from Indo-Persian
miniature painting.
To make this work,
she applied tea stains
to traditional wasli
paper to create a warm
ground, then added
successive layers of
natural pigments and
watercolours to create
an exquisite surface.
The interplay between
figurative and ornamental
imagery is heightened
by the widespread
application of dot
patterning.

KEY FACTS

In 2020, Shahzia Sikander's bronze sculpture *Promiscuous
Identities* was exhibited for the first time in an outdoor setting
at Jesus College, Cambridge, UK.

In 2021, a major exhibition of Sikander's early work was
organized by the Rhode Island School of Design Museum,
Providence, USA. Titled 'Extraordinary Realities', the
exhibition toured the US and was accompanied by a substantial
publication.

KEY WORKS

The Scroll, 1989–90, collection of the artist
Infinite Woman, 2021, Pilar Corrias, London, UK

LUC TUYMANS
BORN 1958, MORTSEL, BELGIUM

Lives and works in Antwerp, Belgium

There is something distinctly creepy about the paintings of Luc
Tuymans. At first glance they appear unassuming. However, on
closer inspection, sinister undercurrents begin to seep to the
surface. Tuymans has acknowledged the dark streak in his work:
'Anything banal can be transformed into horror. Violence is the
only structure underlying my work.' His paintings tackle a range

of challenging subjects, including the Holocaust, paedophilia and colonialism. These subjects are glimpsed rather than directly expressed: an isolated object, an empty room, a close-range mugshot. These oblique references prompt more questions than answers. How do we remember trauma? What do we ever learn from history? What can a painting communicate and what does it withhold?

There is a strong cinematic quality to Tuymans's work. During the early 1980s, he took a break from painting to concentrate on film. This experience left a lasting impression. His work reveals a range of borrowed techniques, including cropping, close-up shots and the building of suspense. The radiating light of the cinema or TV screen is apparent in the eerie greyish-green glow of many of Tuymans's paintings. Photography has also provided an important source of inspiration. Tuymans often works from distressed photographs and faded polaroids, enjoying their tired appearance and reduced ability to provide information. Reflecting this sense of lack, his paintings are often intentionally out of focus. He achieves this by manipulating the surface using deft brushstrokes, enjoying the manipulation of wet paint. Most of Tuymans's paintings are completed within a single day. His creamy, dreamy surfaces are deeply seductive. They draw the viewer in, only to push them out again once the source of the image is recognized. There is beauty and horror, banality and drama, all tangled up on the same surface. The effect is unsettling and peculiarly nauseating.

Luc Tuymans
Bend Over, 2001
Oil on canvas
60 x 60 cm
(23⅝ x 23⅝ in.)
Private collection

The vulnerable pose of this semi-naked figure suggests that a degrading act may have occurred or be imminent. There is a strong sense of claustrophobia heightened by the cropped close-up perspective and reduced colour palette. As chief voyeur of this uncomfortable scene, the viewer becomes complicit.

KEY FACTS

Luc Tuymans has curated many exhibitions, including 'James Ensor by Luc Tuymans' (Royal Academy of Arts, London, 2016–17) and 'Sanguine: Luc Tuymans on Baroque' (Museum of Modern Art, Antwerp, 2018).

The catalogue raisonné of Tuymans's paintings since 1975 now runs to three volumes. It was published by David Zwirner Gallery in 2017 and 2019.

KEY WORKS

Gas Chamber, 1986, Overholland Collection, Amsterdam, the Netherlands
The Shore, 2014, Tate, London, UK

IS MAKING STILL IMPORTANT?

-

I let the material lead me. If it can't say
something, then it better not be made to say it

-

El Anatsui, 2021

Why would an artist bother to make anything these days? How can it be ethical to keep using more of the Earth's resources at a moment of environmental crisis? Museums and galleries use lots of energy to care for their collections: do we really need to increase our carbon footprint by acquiring more art to store, transport and display? Surely sharing art digitally is the way forward – free of red tape, material waste and the claws of commercialism?

In 2021, Christie's made auctioneering history by selling a Non-Fungible Token (NFT) artwork, by the digital artist Mark Winkelmann (more commonly known as Beeple), for $69 million. Titled *Everydays: The First 5000 Days*, this huge compendium of his daily digital creations was the first NFT artwork to be sold at auction. The eye-watering selling price quickly scotched any romantic notions of the digital art market as an accessible and affordable source of art. The art world had discovered a way of privatizing little nuggets of the internet to sell at high prices. Furthermore, NFTs are themselves harmful to the environment, consuming vast amounts of energy. So maybe making objects is not so bad after all?

Even the briefest survey of contemporary art reveals a huge interest in materials and making. Artists are adapting their practices to consider issues of environmental sustainability, with many engaging in processes of scavenging and recycling. Intriguingly, there is a growing interest in human subjects and handmade processes, with a clear resurgence in figurative art and tactile media such as ceramics and textiles. Other artists have looked to the virtual realm as a source of inspiration, creating installations that blend physical and digital content in illuminating ways.

ACCUMULATIONS

There is a clear tendency in contemporary art installations to pile things high and stack them deep. Faced with an overwhelming abundance of stuff, the viewer is made to feel small, and issues of mass production and overconsumption rise to the surface. Often the process of making involves collecting thousands of similar items to create one awesome whole. The use of found or recycled materials can enable the artist to work sustainably. The Ghanaian sculptor El Anatsui has used alcohol bottle seals to create lustrous installations which shimmer like draped fabric.

The sheer abundance of cheap mass-produced things has provided a rich source of inspiration to artists seeking new ways to interpret the everyday. The Indian sculptor Subodh Gupta is drawn

Subodh Gupta
Line of Control, 2008
Stainless steel and steel structure, stainless steel utensils
10 x 10 x 10 m (32 ft 8 in. x 32 ft 8 in. x 32 ft 8 in.)

This work can be read as a strong reaction against weapons of mass destruction. The dynamic accumulation of mass-produced objects also evokes a spirit of productivity and transformation, reflecting India's rapidly growing economy.

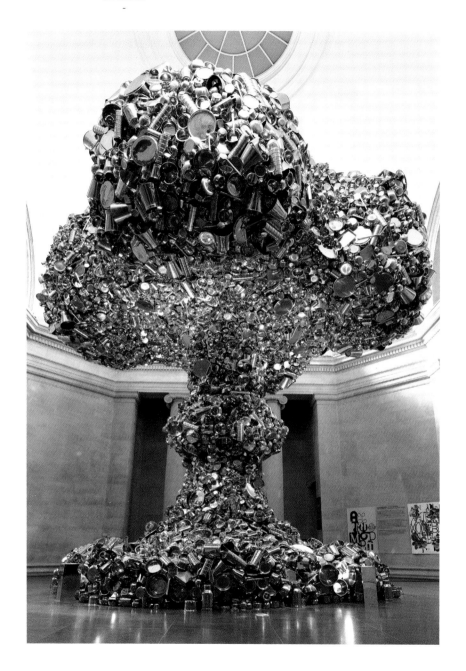

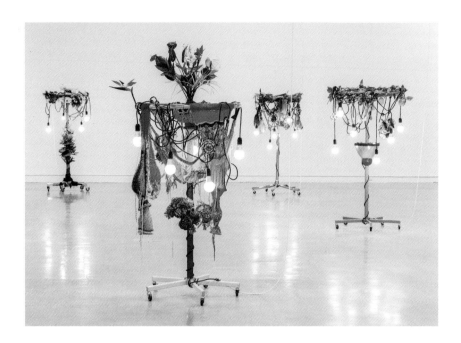

to brand new shiny goods such as tiffin boxes and thali pans, which are commonplace items in India. To make *Line of Control* (2008), Gupta transformed a heap of everyday utensils into a gigantic mushroom cloud. Weighing twenty-six tons and standing ten metres tall, this colossal structure alludes to political tensions between India and Pakistan and operates as a powerful critique of nuclear weapons. As the artist has explained: 'In 1999 I made the first drawing of a mushroom cloud when India and Pakistan were on the brink of a nuclear war. They were having conversations like how many people were going to die if India used its nuclear power. It chilled my heart.'

Sometimes, familiar items can appear strange when placed in unusual contexts or put to unlikely uses. The South Korean artist Haegue Yang (based in Berlin and Seoul) creates striking accumulations of seemingly random items such as fake flowers, lights, window blinds and hand-crocheted knick-knacks. She perceives her poetic configurations to be abstract, and she often employs sound, movement and smell to intensify the encounter with her work. Yang considers her work to reflect 'the topics of migration, displacement, postcolonial diaspora, forced exile'. In bringing random things together, Yang prompts reflection on notions of difference, belonging and community.

Haegue Yang
*Female Native –
Saturation out of Season*,
part of *Female Natives*,
2010
Clothing rack, casters,
light bulbs, cable, zip
ties, terminal strips,
nylon cord, knitting yarn,
artificial plants, split rings,
metal chains, aluminium
reflector, tin can, cane ball
197 x 103 x 103 cm
(77⅝ x 40⅝ x 40⅝ in.)
National Museum
of Modern and
Contemporary Art, Korea

In this work, commercial mobile stands are adorned with artificial materials to create lyrical upright figures. The sound of Igor Stravinsky's radical ballet score *The Rite of Spring* (1913) adds to the suggestion of movement, dance and ritual.

PLACES

Spectacular installations are perfectly suited for presentation in biennial contexts. Art lovers travel long distances to attend a biennial and the expectation is to see something game changing. A visually arresting installation provides perfect social media content, circulating long after a biennial has closed. It can also uncover the hidden narratives of a particular place – a notable landmark or building, or an overlooked space that normally receives limited attention.

There are many other platforms for ambitious, large-scale art to be displayed. The Fourth Plinth project in London, for example, involves an artist making new work for the empty plinth in Trafalgar Square. In New York City, the High Line provides a prominent space for new art on a disused train line. The Turbine Hall in Tate Modern also provides a gargantuan space for major works by an international roster of artists.

The Metropolitan Museum of Art in New York has been programming its stunning roof garden for a series of temporary commissions for over twenty years. A notable example was the 2013 presentation of *And How Many Rains Must Fall Before the Stains Rush Clean* by the Pakistani artist Imran Qureshi. Trained as a miniaturist, Qureshi takes inspiration from the miniaturist paintings of the Moghul Court (1526–1857). From a distance, Qureshi's site-specific work looks like the residue of a violent incident, yet on closer inspection, exquisite blooms and intricate

Imran Qureshi
And How Many Rains Must Fall Before the Stains Rush Clean, 2013
Digital print with hand colouring
61 x 76.2 cm (24 x 30 in.)
Metropolitan Museum of Art, New York

Measuring almost 8,000 square feet, the Metropolitan Museum of Art's roof garden provided a striking setting for Qureshi's floor painting. This work alluded to global violent atrocities and recalls Jackson Pollock's action paintings. Up close, an intricate miniature world of flowers and foliage sprang into view, as can be seen in this related print.

Mark Bradford
*Crack Between the
Floorboards*, 2014
Mixed media on canvas
3.3 x 3 m
(11 ft ⅛ in. x 10 ft ⅜ in.)
Metropolitan Museum of
Art, New York

**Bradford's physical
manipulation of layers of
paint and paper collage
reflects the repetitive
actions of the working-
class protagonists
depicted in Gustave
Caillebotte's *The Floor
Planers* (1875) and builds
a sense of empathy and
solidarity.**

vegetation emerge. As Qureshi has explained: 'these forms stem
from the effects of violence. They are mingled with the color of
blood, but, at the same time, this is where a dialogue with life, with
new beginnings and fresh hope starts.'

Materials can be used in many ways to evoke a sense of place.
The American artist Sheila Hicks has undertaken extensive global
travels to inform her textile-based practice, learning new skills and
techniques. In the work of fellow American artist Mark Bradford,
a sense of place is embedded in his choice of materials. Working
on a large scale, he builds up layers of paper, rope, caulk and other
materials from the hardware store to connect marginalized people
and locations. *Crack Between the Floorboards* (2014) references a
painting by Gustave Caillebotte called *The Floor Planers* (1875).
This famous work depicts a group of shirtless working-class men
sanding the floor of a bourgeois Parisian apartment. Bradford
responded with an abstract parquet composition built from layers
of carbon paper and posters sourced from his neighbourhood in Los
Angeles. In referencing past and present notions of work, Bradford
reflects on the representation of labour, class and masculinity.

NETWORKS

Nam June Paik
Electronic Superhighway:
Continental U.S., Alaska,
Hawaii, 1995
51 channel video
installation (including one
closed-circuit television
feed), custom electronics,
neon lighting, steel and
wood; colour and sound
4.57 x 12.19 x 1.22 m
(15 x 40 x 4 ft)
Smithsonian American
Art Museum,
Washington, DC

**Paik first visited the USA
in 1964. At the time, the
interstate highways were
relatively new, offering
new opportunities to
explore. Paik's use of
neon delineates each of
the fifty-one states of the
USA and recalls roadside
advertising signage.**

There is a spirit of networking and connectivity in much
contemporary art. Many artworks feature elements from fine
art, everyday and digital sources, linked together in various
configurations. This tendency may arise from our increasingly
connected, globalized world driven by the internet. For millions of
people, daily life now involves the continual negotiation of real and
digital content. There are many examples of this approach, from
the delicate room-sized installations of Sarah Sze to the intricate
paintings of Julie Mehretu.

Of course, artists incorporated electronic forms into their work
long before the invention of the internet. The South Korean artist
Nam June Paik is considered to be the founding figure of Video
Art. He began to experiment with television back in 1963 and he
coined the phrase 'electronic superhighway' back in the 1970s.
Paik famously stated: 'Skin has become inadequate in interfacing
with reality. Technology has become the body's new membrane
of existence.' *Electronic Superhighway: Continental U.S., Alaska,
Hawaii* (1995) acknowledges how screen-based media informs our
perception of a place and its culture. To make this major installation,
Paik stacked 366 television sets to form a map of the USA. Each

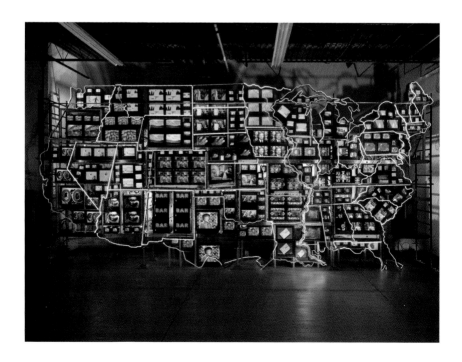

'state' of TVs presents a particular example of classic 'American' footage. Paik's work reminds us that screen-based media follows us wherever we may wander.

The internet brings many benefits, but there is a darker side emerging from its ability to survey our desires and influence our thinking. The German artist Hito Steyerl makes multimedia installations which operate as visual essays or poems, examining life in the internet age. *HellYeahWeFuckDie* (2016) presents several videos in a carefully constructed environment in which concrete and neon seating spells out the most frequently used words in recent popular music. The videos reveal a range of conflicting scenarios, from a lesson teaching a robot how to deal with conflict to a child asking Siri about the nature of war. This work conveys a strange dystopian world built using powerful technologies yet fuelled by essentially human behaviours.

FIGURES

With all of these developments across physical and digital media, you might be forgiven for thinking that the age-old subject of the human body was well out of date. Not so! There has been a huge renaissance in figurative art and human subjects in recent years, as evidenced in major exhibitions and presentations. Simone Leigh

Hito Steyerl
HellYeahWeFuckDie, 2016
Three-channel HD
video file 'Hell Yeah',
single-channel HD video
file 'Robots Today' and
five lightboxes.
4 minutes 35 seconds

This installation was originally made for the 2017 edition of Skulptur Projekte Münster, a major exhibition taking place across the city every ten years. Steyerl chose the slick foyer of a bank as the setting for her work, its walls adorned with works of Modernist art. Her dystopian vision created a suitably unsettling contrast, suggesting an alternative view of the future.

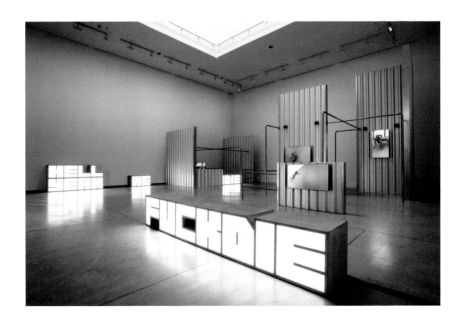

Lynette Yiadom-Boakye
No Need of Speech, 2018
Oil on canvas
230 x 247.4 cm
(90⅝ x 97½ in.)
Carnegie Museum of Art,
Pittsburgh

Yiadom-Boakye likes to
finish her paintings in one
day, painting wet on wet
rather than allowing the
oils to dry. This approach
gives her work freshness
and spontaneity.
Nevertheless, her
compositions are always
carefully considered.
Yiadom-Boakye
rarely works from life,
preferring to respond to
imagery from magazines,
scrapbooks and
memories.

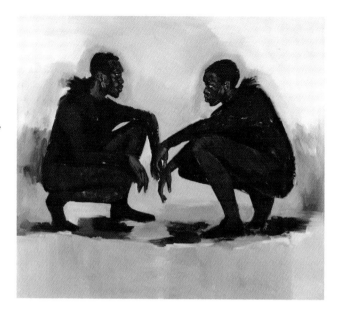

represented the United States at the 59th Venice Biennale in 2022
with figurative sculptures made from a wide range of materials
including ceramic and raffia.

Contemporary representations of the body often combine traditional methods with fresh ideas

The British painter Lynette Yiadom-Boakye has achieved
international recognition for her painterly representation of
fictitious black characters. Seemingly bored, listless or unconcerned,
her languorous figures recall the grand posturing of historical
portraiture by generations of artists including John Singer Sargent.
The influence of Édouard Manet and W. R. Sickert can also be
discerned in her loose and gestural handling of paint. As the artist
explains: 'I learned how to paint from looking at painting and I
continue to learn from looking at painting. In that sense, history
serves as a resource. But the bigger draw for me is the power that
painting can wield across time.'

Other artists have looked far beyond the art world for inspiration
and materials. The French artist Pierre Huyghe is interested in
creating new networks and pathways between different kinds

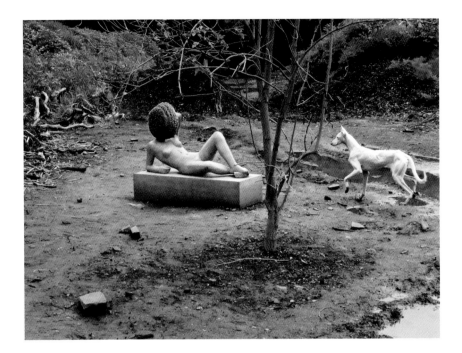

of intelligence: human, animal and technological. In one of his most iconic works, *Untilled (Liegender Frauenakt)* (2012), Huyghe replaced the head of an idealized reclining female figure with a live colony of bees. Suddenly, the site of a single human brain becomes home to a complex network of collective intelligence and activity. Huyghe considers the work to be an active collaboration, with the insects contributing to the production and content.

For artists today, making is a process that involves a glance to the past, a nod to the present and a glimpse of the future, but it can also involve sideways approaches to other means of production. This is fertile territory offering many new possibilities. Making remains an important form of creative thinking.

Pierre Huyghe
*Untilled (Liegender
Frauenakt)*, 2012
Concrete with beehive
structure, wax and live
bee colony
Figure 75 x 145 x 45 cm
(29½ x 57⅛ x 17¾ in.),
base 30 x 145 x 55 cm
(11¾ x 57⅛ x 21⅝ in.),
beehive dimensions
variable
Museum of Modern Art,
New York

**Huyghe is interested in
auto-generative art: art
that makes itself. He is
also fascinated by the
'rhythms, automatisms ...
accidents and continuous
transformations' found
in nature. To create
this work, Huyghe
collaborated with a live
colony of bees, timing
the display of the work
around their natural
cycles of activity. Time
is therefore another
important component.**

KEY IDEAS

Making remains a crucial activity for many contemporary artists.
The accumulation of existing materials has led to the creation of
spectacular installations.
Producing work for a specific context can prompt intriguing
connections and narratives.
Traditional genres, such as figuration, have been invigorated
through the use of new materials and sources of inspiration.

KEY ARTISTS

Nairy Baghramian | Alvaro Barrington | Huma Bhabha | Abraham
Cruzvillegas | Helen Marten | Magdalene Odundo | Martin
Puryear | Chiharu Shiota | Dana Schutz | Cecilia Vicuña

KEY ACTIVITIES

Go and see some art in an outdoor, public setting. How does the
location dictate the choice of materials? Why do you think the
artist chose this site?
If you can, visit a biennial or a similar multi-venue art festival. If
this is not possible, 'visit' a current biennial digitally.
Check out the website and the related social media activity. What
is causing a stir?

EL ANATSUI
BORN 1944, ANYAKO, GHANA

Lives and works in Nsukka, Nigeria

In the late 1990s, El Anatsui stumbled across a bag of old liquor bottle seals by the side of the road. This chance encounter changed the direction of his art. Anatsui had often used found objects in his sculpture, but there was something about these shiny castoff clasps that sparked a new stream of ideas. He discovered that he could bend, crumple and twist the seals into desired shapes before stitching them together using copper wire to create sumptuous and malleable surfaces. Anatsui considers his bottle seal works to occupy a space between painting and sculpture. They point to a range of issues, including the environment, consumerism and colonial trade histories. The *New York Times* art critic Roberta Smith wrote: 'The works evoke lace but also chain mail; quilts but also animal hides; garments but also mosaic, not to mention the rich ceremonial cloths of numerous cultures. Their drapes and folds have a voluptuous sculptural presence, but also an undeniably glamorous bravado.'

El Anatsui's works often assume epic proportions, suspended from walls in galleries or draping casually over the facades of major buildings to spectacular effect. He avoids fixed installation instructions, preferring to invite others to decide on the final arrangement and to let the material speak for itself. To produce art on this scale involves a considerable network of support. Working from a substantial studio space in Nsukka, Nigeria, Anatsui now acquires industrial quantities of seals delivered from local recycling centres and employs a large team from the local community to help him produce the work. This collective spirit is important to Anatsui, who has stated: 'What I'm interested in is the fact of many hands. When people see work like that, they should be able to feel the presence of these people.'

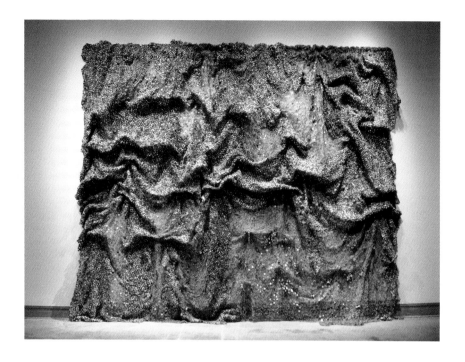

El Anatsui
Dusasa II, 2007
Found aluminium, copper
wire and plastic discs
5.5 x 6.6 m
(17 ft 11⅛ in. x 21 ft 6 in.)
Metropolitan Museum of
Art, New York

Anatsui's work achieved
significant international
attention when it was
exhibited at the 52nd
Venice Biennale in 2007.
He famously draped a
work across the facade
of the historic Palazzo
Fortuny to spectacular
effect. *Dusasa II* was
presented in Venice's
impressive Arsenale
building. Anatsui has
explained that the title
of this work refers to
'communal patchwork
made by a team of
townspeople'.

KEY FACTS

In 2015, El Anatsui was awarded a prestigious Golden Lion
Lifetime Achievement Award at the 56th Venice Biennale.
A major solo exhibition, 'Triumphant Scale', opened at Haus Der
Kunst, Munich, in 2019. Curated by Okwui Enwezor and Chika
Okeke-Agulu, the show toured to the Arab Museum of Modern
Art, Doha, and Kunstmuseum Bern.

KEY WORKS

Straying Continents, 2010, Royal Ontario Museum, Toronto,
Canada
Tsiatsia – Searching for Connection, 2013, Zeitz Museum of
Contemporary Art Africa, Cape Town, South Africa

SHEILA HICKS
BORN 1934, HASTINGS, NE, USA
Lives and works in Paris, France, and New York City, USA

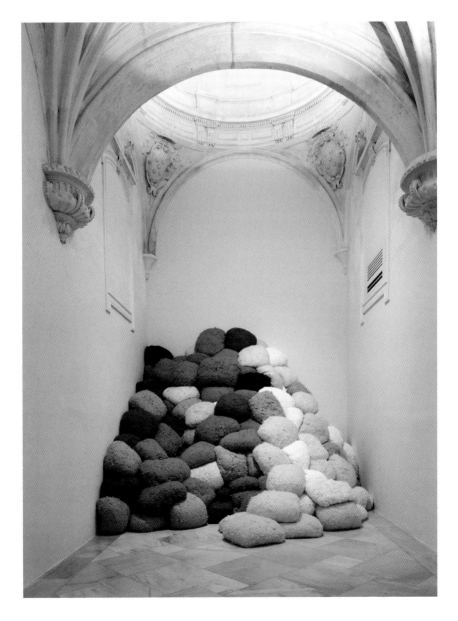

Sheila Hicks
La Sentinelle de Safran,
2018
Pigmented acrylic fibre
Dimensions variable

La Sentinelle de Safran
**comprises a mountain
of pigmented fibre
bundles. Hicks has
expressed an interest in
working collaboratively
with nature, industry
and people. She has
described this work as
resulting from a chain
of interactions: 'taking
pigment from the earth,
transforming it with
acrylic, and then sending
it to spinners, who can
make it into a line, into a
thread'.**

Sheila Hicks started out as a painter. She studied at Yale University under Josef Albers, whose refined use of colour provided an important source of inspiration. In the mid-1950s, Hicks was awarded a Fulbright Grant to study ancient Andean textiles in Chile. Travelling in South America convinced her to switch permanently to working with fibre. She has since ventured across five continents, discovering a strong sense of connection and shared purpose: 'In all of the cultures of the world, textile is a crucial and essential component. … There's a level of familiarity that immediately breaks down any prejudice.' Working alongside fellow artists and craftspeople, Hicks has built an extraordinary body of knowledge. She considers this to be an ongoing process of enlightenment, explaining: 'I don't want to go do something I know how to do. I want to go do something I *don't* know how to do.'

Hicks became a leading figure in the Fiber Art movement of the 1960s and 1970s, one of several women pushing new approaches to working with textiles and fibre. Her work featured in a number of important exhibitions, including 'Wall Hangings' at the Museum of Modern Art, New York, in 1969. Her practice involves weaving, wrapping and bundling fibres to build abstract, tactile, brightly coloured forms. Her work can assume monumental proportions, occupying public spaces to spectacular effect. She stacks bales of fibre into colossal mountains and suspends skeins of thread from the ceiling to create cascades of pure colour. In smaller works, such as her 'Minimes' series, Hicks has created intimate weavings using wooden looms, embedding materials such as slate and razor clams into her work. Whatever her chosen scale, Hicks is resolute in her determination to work across art, craft, architecture and design to forge new material possibilities.

KEY FACTS

Weaving as Metaphor, a substantial book charting fifty years of Sheila Hicks's art, was published in 2006. Designed by Irma Boom, the book won a Gold Medal for 'Most Beautiful Book in the World' at Leipzig Book Fair, Germany.
In 2018, a major retrospective exhibition titled 'Lignes de Vie (Life Lines)' was staged at the Centre Pompidou, Paris, France.

KEY WORKS

Palitos con Bolas, 2011, Centre Georges Pompidou, Paris, France
Pillar of Inquiry/ Supple Column, 2013–14, Museum of Modern Art, New York, USA

SIMONE LEIGH
BORN 1967, CHICAGO, USA

Lives and works in New York City, USA

Simone Leigh originally intended to be a social worker, but gradually concluded that art was her true vocation. Whether working in sculpture, installation, video or performance, Leigh operates with a strong social conscience and foregrounds the lives, experiences and histories of black women. She applies her deep knowledge of African and African American art to challenge presumptions of race, gender and beauty. Leigh has also championed the use of ceramics, sticking with the medium despite frequent warnings that she would never make it within contemporary art circles. Leigh has recently received international recognition for her figurative sculptures which embrace a range of materials and ethnographic sources. She is philosophical about the benefits of having been 'largely ignored', explaining, 'I had a long time to mature without any kind of glare.' The women in Leigh's sculptures appear poised, dignified and resilient. They occupy contemporary space, yet they also refer to different times and places. Their facial features are simplified and non-specific, enabling them to speak for many. Their bodies are often surrounded by elaborate skirts made from raffia or ceramic. These voluminous forms reference various architectural structures, from teleuk clay dwellings built by the Mousgoum people of Cameroon and Chad, to Batammaliba architecture found in Benin and Togo. Leigh has also alluded to *Mammy's Cupboard*, a highway restaurant south of Natchez, Mississippi, shaped to represent a black woman's body. In smaller ceramic pieces, Leigh refers to face jugs which were popular in the American South during the 1890s. These domestic vessels aligned the black body with usefulness and ugliness. Leigh's versions bestow beauty, dignity and agency to this vernacular form. The alluring glossy surfaces of her salt-kiln glaze sculptures glisten, deflecting any untoward gaze. Leigh's sculptures secure a space for personal autonomy and deep reflection.

Simone Leigh
Planet, 2021
Stoneware, metal and raffia
2.53 x 1.13 x 1.19 m
(8 ft 4 in. x 3 ft 8½ in. x 3 ft 11⅛ in.)

Leigh enjoys hands-on working processes even when working on a large scale. She chooses tactile materials such as clay, gold leaf and raffia and her gestures can be traced in the surfaces of her work. Leigh's use of raffia references marronage, a moment in history when people escaped slavery to build makeshift settlements in the harsh terrains of America's southern states.

Simone Leigh
Face Jug (COBALT),
2020
Noborigama fired
porcelain
45.7 x 19.7 x 21.3 cm
(18 x 7⅞ x 8½ in.)

**The features in Leigh's
works are often
streamlined to give
a stately, dignified
appearance. Leigh
has explained: 'It's a
way of abstracting the
figure because as I work
I imagine a kind of
experience, a state of
being, rather than one
person.' In this piece
the eyes are barely
discernible and the floral
rendering of the hair adds
an elegant, decorative
touch.**

KEY FACTS

Simone Leigh was the first artist commissioned to make a work for
the High Line Plinth in New York City. She responded with *Brick
House* (2019), a bronze sculpture of a black woman standing
sixteen feet tall and weighing 5,900 lb.

In 2022, Leigh became the first black woman to represent the
United States at the Venice Biennale and won the prestigious
Golden Lion award.

KEY WORKS

Cupboard VIII, 2018, Whitney Museum of American Art,
New York, USA

Las Meninas, 2019, The Cleveland Museum of Art, Ohio, USA

JULIE MEHRETU
BORN 1970, ADDIS ABABA, ETHIOPIA

Lives and works in New York City, USA

Finding your way through one of Julie Mehretu's paintings is not always easy. On the face of it, her large-scale paintings have the route-finder quality of a map. She often starts out by plotting imagery from technical drawings and plans of urban spaces onto the picture surface. She then builds up layers of free drawing, sweeping lines and dashing zones of pure colour. Mehretu creates a vortex of ideas and possibilities, positioning the city as a site of constant energy, movement and transformation. Although made by hand, her works convey a strong digital presence. Mehretu considers her work to reflect the morphed energy of our real and virtual experience of contemporary life: 'We are constantly negotiating ourselves

in this world, as well as a projected digital mimeograph of it, that is completely contradictory and confusing and complicated. [...] Today, there are many ways to think about everything, which just as quickly morphs and flattens into a kind of weird reflecting mirror, twisting completely into something else.'

In building her vision of the present, Mehretu makes frequent references to the past. She uses all the ingredients of a classic Modernist painting: a large scale, paint on canvas, abstract gestures. It is possible to observe the frenetic urban buzz of Futurism, the multiple views of Cubism, the layered abstraction of Russian Constructivism and the all-over mark making of Abstract Expressionism. Yet, Mehretu's vision is distinctly contemporary, drawing on social issues, conflicts and challenges. She draws inspiration from how cities reflect individual and collective behaviours and identities. Her recent work has been informed by documentary imagery of social and political unrest and evidence of injustice. Mehretu does not represent this material directly but instead uses it to provide an overall context, a mood, a vital source of chaos and restless energy.

Julie Mehretu
Stadia II, 2004
Ink and acrylic on canvas
2.7 x 3.6 m
(8 ft 12 in. x 11 ft 7⅞ in.)
Carnegie Museum of Art,
Pittsburgh

This work forms part of a triptych of paintings exploring the role of the stadium in nationalistic and revolutionary pursuits. Arcs and swirling lines combine to suggest an arena or amphitheatre. Fluttering zones of colour recall the confetti and banners of sporting events and political rallies. The viewer is left to decide if this is a site of celebration or horror.

KEY FACTS

In 2019, a major mid-career retrospective of Julie Mehretu's work launched at the Los Angeles County Museum (LACMA), Los Angeles, before touring to the Whitney Museum of American Art, New York, in 2021.

Mehretu featured in *Time* magazine's Most Influential People of 2020 list.

KEY WORKS

HOWL, eon (I, II), 2016–17, Collection SFMOMA, San Francisco, USA
Haka (and Riot), 2019, Los Angeles County Museum of Art, Los Angeles, USA

SARAH SZE
BORN 1969, BOSTON, USA

Lives and works in New York City, USA

One of the first things that Sarah Sze does before starting one of her multimedia installations is to visit the nearest hardware store. Going local enables Sze to root her work in a particular place. Her extensive shopping list of random objects might include cotton buds and matchboxes, house plants and garden lamps, plastic bottles and tea bags, drawing pins, wire and string. Normally these random fragments fail to capture our attention, yet, in the hands of Sze, they are elevated to become crucial pieces in a veritable jigsaw of matter. Sze's interest in combining many small things into a larger whole stems from a desire to break down the idea of sculpture as 'a solid form that has to do with finite geometric constitutions, shapes, and content'. This open and mutable approach enables Sze to allude to many different entities all at once, from the miniscule to the gigantic. Her networked scapes suggest the invisible infrastructures of the internet, a fast-paced megacity, or even a distant galaxy.

Sze's intricate installations are assembled with a painstaking attention to detail. Spanning wall, floor and ceiling, they dangle and drape, spreading their entrails to inhabit every inch of a given space. This is a precarious domain: one false move and the whole scheme might collapse. Sze enjoys this tension and aims for her work to achieve a 'constant state of flux in terms of how it exists in space, how it exists in time; it should be unclear whether it's in a process of becoming or a process of entropy. Precarious is such a nice word because usually I think in terms of fragility, but precariousness implies the potential to go somewhere; it implies the tension of the next step. If I can find that, then a sculpture is working.'

Sarah Sze
Triple Point (Pendulum),
2013
Salt, water, stone,
string, projector, video,
pendulum and mixed
media
Dimensions variable,
approx. 3.8 x 5.3 x 5 m
(12 ft 6 in. x 17 ft 6 in. x
16 ft 8⅛ in.)
Museum of Modern Art,
New York

**Sze's interest in using
sculpture to embrace
various states of being
is reflected in the title
of this multimedia
installation, which
denotes the point at
which water can be liquid,
gaseous or solid. The
addition of a pendulum
adds dynamism. This
work was first presented
in the American Pavilion
at the 55th Venice
Biennale in 2013.**

KEY FACTS

The daughter of an architect, Sarah Sze originally studied
Architecture and Painting at Yale University. Painting has
played a more prominent role in her recent work.

Sze has made several works for outdoor settings and public spaces,
including major commissions for the High Line, LaGuardia Airport
and the 96th Street subway station in New York City.

KEY WORKS

Fixed Points Finding a Home, 2012, MUDAM Luxembourg,
Luxembourg

Shorter than the Day, 2020, permanent installation, LaGuardia
Airport, New York, USA

CAN ART BUILD
A BETTER WORLD?

-

As an artist I have to relate to humanity's
struggles ... I never separate those situations
from my art

-

Ai Weiwei, 2016

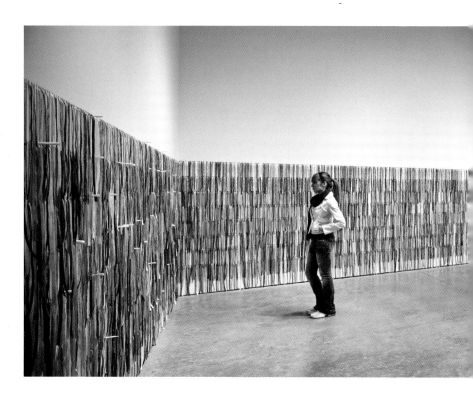

Is it enough for art to inspire us, to get us thinking and to stimulate our senses, or should art contribute to society in more constructive ways? This is the million-dollar question in the art world right now, with many artists, curators and institutions pondering the true purpose of art. An increasing number of people believe that art should be more useful, that it should engage with individuals and communities to effect change. This has led to a review not just of the role of artists in society but also to the function and nature of galleries and museums. Should an arts institution strive to be a neutral space accommodating a wide range of perspectives, or is there scope to be more political, more activist, pushing agendas?

This final chapter explores the potential of art to improve the world. It highlights how artists have used their status and global reach to effect change. Many artists want to reach out to engage with audiences in more direct ways. These socially engaged practices often involve other people and tackle current social and political issues in an urgent or confrontational manner.

Rivane Neuenschwander
I Wish Your Wish, 2003
Silkscreen on fabric
ribbons
Dimensions variable
Gallery of Modern Art,
Queensland

This participatory work comprises a sea of colourful ribbons tacked to the wall. Each ribbon is inscribed with a different wish. Visitors are invited to take a ribbon to wear on their wrist in the hope that the wish will come true. Visitors can also contribute their own wishes to be made into new ribbons for future display.

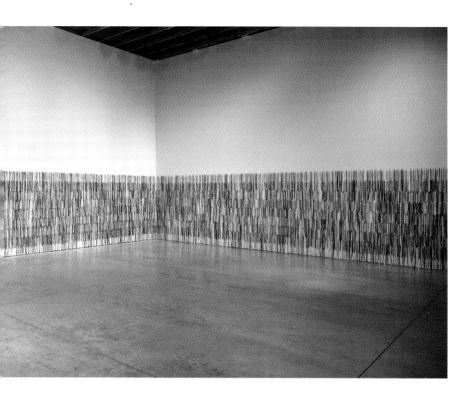

TAKING PART

Participation has become a very important aspect of socially engaged practice. Artists have reached out to communities, inviting them to join in with the processes of making art. In working with others, artists hope to make their work more relevant and useful. A similar spirit of co-production is happening in museums and galleries. Who needs a curator when members of the public can develop exhibitions for themselves? In removing individual egos and specialisms, co-curation can build a sense of authenticity and harness different kinds of knowledge. But there are risks involved with participatory practice. Despite the apparent spirit of openness and inclusion, the artist or venue usually maintains overall authorship and financial control. The organizing curator rarely works for free, but the participants often do. Issues of fair pay remain unresolved in many contexts.

There are many different levels of participation, from the light-touch invitation to share an idea in a gallery space, as evidenced in the work of the Brazilian artist Rivane Neuenschwander, through to substantial paid opportunities to create ambitious community schemes as initiated by the artist Theaster Gates in downtown

Chicago. Many artworks emerge as social forums and hubs: places to linger, research and contribute. The German artist Thomas Hirschhorn has worked with communities to build several makeshift 'monuments' dedicated to his favourite philosophers. Built from low-cost, makeshift materials, these temporary structures provide spaces for the community to work, play, think and create. *Gramsci Monument* (2013) was built with a local community in The Bronx, New York. It featured a library, access to key texts, a place for children to learn, a radio station and internet access. A regular programme of events, including performances, readings and art classes, took place for the duration of the work's existence. Although Hirschhorn's monuments are temporary, he hopes that they will inspire lasting change.

The participants invited to work with the Spanish artist Santiago Sierra are also paid for their contributions. Sierra invites low-paid workers and marginalized communities to take part in mundane, futile and often degrading actions, reflecting the practices of capitalist society. He once paid a group of minimum-wage workers to push a concrete block around the gallery. Perhaps his most notorious work involved paying four drug-addicted sex workers the price of a fix of heroin to have a 160 cm straight line tattooed across their backs. These transactions reflect the challenging realities of life for many individuals. Framing their actions as art makes for uncomfortable viewing.

Santiago Sierra
250 cm Line Tattooed on the Backs of 6 Paid People
Espacio Aglutinador, Havana, December 1999,
1999
Cibachrome on PE-paper
150 x 216 cm
(59⅛ x 85⅛ in.)
DZ BANK Art Collection at the Städel Museum, Frankfurt

To make this work, the second of Sierra's actions involving tattooing, the artist invited six low-paid workers to have a 250 cm line tattooed across their backs for cash. Keen for the money, the workers agreed. As Sierra explains: 'the tattoo is not the problem. The problem is the existence of social conditions that allow me to make this work.'

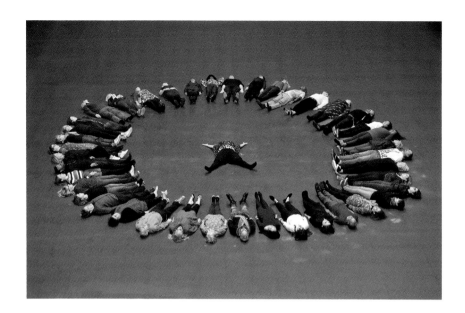

Tania Bruguera
10,142,926, 2019
Tate Modern, London

This subtle intervention occupied the expansive floor of the Turbine Hall at Tate Modern in London. Body heat from the participating audience activated the heat-sensitive floor surface to reveal an image of Yousef, a young migrant who fled Syria for London. His poignant portrait could only emerge through the collective actions of many people.

TAKING ACTION

Making art can be an excellent way of drawing attention to current political issues. Some artists have used their international status to reveal stories that might otherwise go unnoticed. This, of course, can lead to significant discomfort for those in power wishing to conceal uncomfortable truths. Perhaps the most famous example of an artist willing to challenge political authority is Ai Weiwei. His works tackle specific social issues and he has also used social media in canny ways to attract maximum attention. Ai's criticism of political control in his home country of China led to his arrest and detainment in 2011, causing global outrage. The Cuban artist Tania Bruguera has also been detained by the authorities because of her activist practice. In 2014, she was banned from staging her participatory performance *Tatlin's Whisper* in the Plaza de la Revolución in Havana. The work involved members of the public standing on a platform and speaking on a subject of their choice for one minute before being escorted away by uniformed officials. Bruguera describes her work as *Arte Útil*, 'useful art', and she engages in long-term and participatory projects with the intention of creating genuine social change and a more inclusive society. Her 2019 commission for Tate Modern involved subtle interventions on the subject of migration. The title of the commission, *10,142,926*, reflected the number of people who had migrated from one country to another during the preceding year, plus the number of migrant deaths during 2019. The title increased

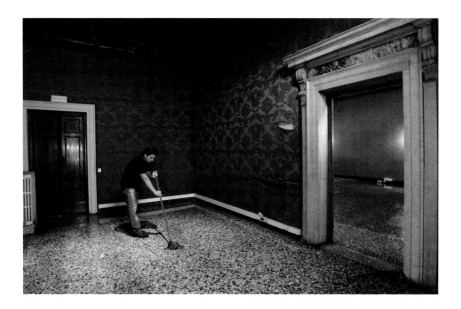

in number as the death count grew. The subject of loss has been handled by contemporary artists in poignant and visceral ways. The Colombian artist Doris Salcedo has incorporated human hair, clothing and furniture into her work to acknowledge the many individuals who have 'disappeared' during political conflicts. Teresa Margolles salvages the grisly materials resulting from drug-related murders in her home country of Mexico. In 2009, Margolles represented Mexico at the 53rd Venice Biennale. Her installation, *What Else Could We Talk About?*, featured a display of suspended blood-stained fabrics found at narco-murder scenes. Each day, Margolles used gold thread to embroider the fabrics with threatening messages left by the perpetrators, such as 'SO THAT THEY LEARN TO RESPECT'. The private view card took the form of a credit card, with one side featuring the image of a narco-murder victim and the other bearing the simple inscription: 'card to cut cocaine'. Through this gesture, Margolles highlighted the art world's complicity in this relentless and tragic situation.

TAKING CARE

There is a lot of talk in the art world about environmental sustainability and caring for the planet. Yet, despite all the policies, statements and working groups, the art world maintains its perpetual cycle of art fairs, exhibitions and biennials. These rely on a relentless

Teresa Margolles
¿De qué otra cosa podríamos hablar? Limpieza (What Else Could We Talk About? Cleaning), 2009 Installation consisting of a repeating performance carried out by up to three people mopping the floors of the exhibition space with a mix of water obtained from humidifying fabrics that previously absorbed fluids and leftovers of crime scenes in different cities of northern Mexico

A key element of this multilayered installation for the 53rd Venice Biennale was the daily cleaning of the floors of the Mexican Pavilion using diluted blood taken from sheets used to cleanse crime scenes. Although invisible, these traces added to the unnerving atmosphere.

supply of materials and an exhausting schedule of international
travel for artworks, artists, curators, assistants, technical and media
staff and, of course, visitors!

Rashid Johnson
Antoine's Organ, 2016
Black steel, grow lights,
plants, wood, shea butter,
books, monitors, rugs,
piano
4.8 x 8.6 x 3.2 m
(15 ft 9⅛ in. x 28 ft 2 in.
x 10 ft 6¾ in.)

**This substantial artwork
creates a veritable
ecosystem in the gallery
space. It establishes a
community of plants,
handmade vessels and
objects of African origin
within a Minimalist black
steel gridded sculpture. A
piano occupies the heart
of the work, enabling a
sonic aspect. Johnson
considers the work
to operate as a living,
thinking organism, a kind
of brain.**

Many artists today engage in debates and actions concerning the protection of the environment

They seek to use their status to encourage change and to propose
more efficient ways of living and working.

There is a growing spirit of care and social responsibility in
contemporary practice, as evidenced in the work of Rashid Johnson
and Otobong Nkanga. Johnson incorporates plants into some of
his works to create living environments that depend on human
actions to flourish. Equally prevalent is a desire to reflect on future
possibilities, proposing solutions that might help us to adapt to
increasingly challenging conditions. The American artist Mary
Mattingly considers the skills and structures we might need
to survive in a future of relentless environmental migration.
She has devised simple nomadic homes which could be adapted
to fit on a raft or even a bicycle. She has also assessed her personal
possessions, bundling them together to create gigantic globes
which she has pushed around the streets of New York City.

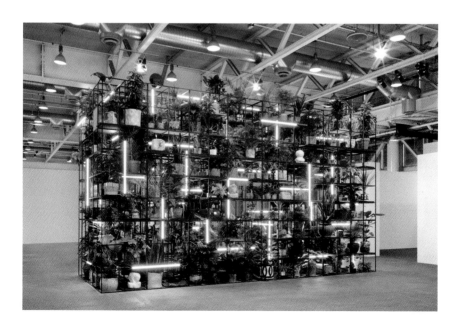

Mary Mattingly
Life of Objects, 2013
Chromogenic dye
coupler print
76.2 x 76.2 cm
(30 x 30 in.)

Mattingly hopes that the
future will be driven by a
spirit of community and
cooperation rather than
the current obsession
with material goods. In
this work, a bundle of
material possessions
threatens to overwhelm
a lone naked figure. The
work recalls the Greek
myth of Sisyphus, who
was forced to push a
boulder up a hill for all
eternity.

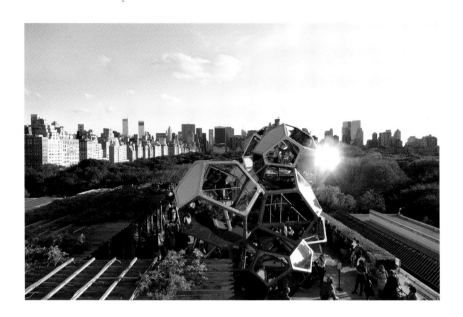

Tomás Saraceno
Cloud City, 2012
Installation view
Metropolitan Museum
of Art, New York

**Saraceno liaised with
biologists, engineers and
space architects to create
Cloud City. Employing
a range of hi-tech,
sustainable materials, this
visionary architecture
proposed the possibility
of airborne communal
living. The airy structure
stood over 15 m (49 ft)
tall and featured sixteen
interlinked room-sized
pods.**

These performances act as practice runs for a perilous future and offer a stark reminder of our commodity-driven culture.

Speculative imaginings also underpin the work of the Argentinian artist Tomás Saraceno. His solution to environmental catastrophe is to elevate our living spaces above ground. Trained as an architect, Saraceno blends imaginative thinking with acute technical understanding. His major installation *Cloud City* was first presented on the roof space of the Metropolitan Museum of Art in 2012. This complex structure of pentagonal and hexagonal forms proposed a new way of living, up in the clouds. Whatever the future holds, 'blue sky' creative thinking will be helpful in tackling the challenges ahead.

DIRECT MESSAGING

The art world loves a good slogan. Print your message in bold block lettering across a brightly coloured cotton tote or a monochrome unisex t-shirt, and you can become an activist in seconds. Spread the word and change the world.

Artists have used various methods to deliver key messages, from manifestoes and poster campaigns to the use of light and neon to make bold statements

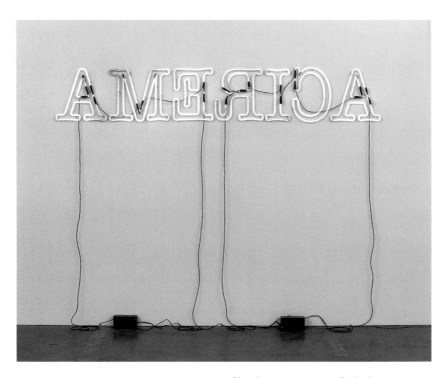

Glenn Ligon
Rückenfigur, 2009
Neon and paint, edition
of 3 and 2 APs
61 x 368.3 x 10.2 cm
(24 x 145 x 4 in.)

**Rückenfigur means
'back figure' in German.
It references a trope in
painting whereby we
observe a figure from
behind who in turn
surveys a scene in front
of them as in Caspar
David Friedrich's famous
painting *Wanderer above
the Sea Fog* (c.1818). In
Ligon's work, the viewer
also assumes a back
position, able to survey
the breadth of 'America'
from a unique viewpoint.**

Many of these strategies are long established. In the early twentieth century, artists associated with Futurism and Vorticism produced dynamic manifestoes delivered in shouty block capitals and strong typographic treatments. Since the 1980s, the feminist activist group the Guerrilla Girls have mounted highly visible campaigns to advocate for intersectional equality within the art world.

Words and text occupy the heart of Glenn Ligon's art. Using a range of media from painting and drawing to neon lettering, he explores his experiences as a black, gay man living in America. He often uses the contrast between black and white to play on notions of difference. At first glance, the work *Rückenfigur* (2009) appears to be a straightforward neon sign spelling the word 'America'. However, on closer inspection it becomes clear that the letters have been reversed. By effectively standing behind the letters, the viewer has a greater opportunity to look through, out and across, surveying 'America' with all its complexity and contradictions.

Since the 1970s, the influential American artist Jenny Holzer has explored the powerful potential of writing. Her work assumes a very public presence, appearing on billboards, fly posters and bright neon signs. In a recent series of work called *VIGIL* (2019), Holzer shone personal testimonials evidencing the impact of gun violence onto major buildings across New York City. Impossible to miss, these poignant statements assumed epic proportions and glowed in the dark. In positioning her work in the heart of the city, Holzer hoped to provoke a wider conversation and to confront 'ugly truths'.

Artists have used many strategies to make their work relevant and socially conscious. Will this domain eventually eclipse all other forms of making? Will public funding dry up for artists not seeking usefulness as a direct principle? If so, what would be lost in the process? It remains to be seen if art can substantially change the world, but it is heartening to reflect on the many collective and individual efforts to make things better.

KEY IDEAS

Artists and curators have developed participatory processes to increase the relevance of their work.

Some artists have engaged in activism to tackle specific social and political issues.

Environmental concerns continue to grow, with artists harnessing sustainable ideas and approaches.

Artists continue to harness the power of words to convey political messages in bold and direct ways.

KEY ARTISTS

Oreet Ashery | Barbara Kruger | Suzanne Lacy | Liu Xiaodong | Rick Lowe | David Medalla | Cildo Meireles | Yoko Ono | Pussy Riot | Sean Starowitz

KEY ACTIVITIES

Take an environmentally friendly approach to gallery-going by supporting the artists and venues in your local area.

Check out the participatory opportunities in your local gallery and consider joining in. It can be a great way of forging new friendships with fellow art aficionados.

Jenny Holzer
VIGIL, 2019
Light projection,
Rockefeller Center,
New York

This installation involved the projection of powerful and emotive gun violence testimonials onto New York City buildings at night. The texts were sourced from the book and website *Bullets into Bells: Poets Respond to Gun Violence* and from stories shared on Everytown for Gun Safety's website, *Moments that Survive.* Holzer also used poems written by teens affected by mass shootings.

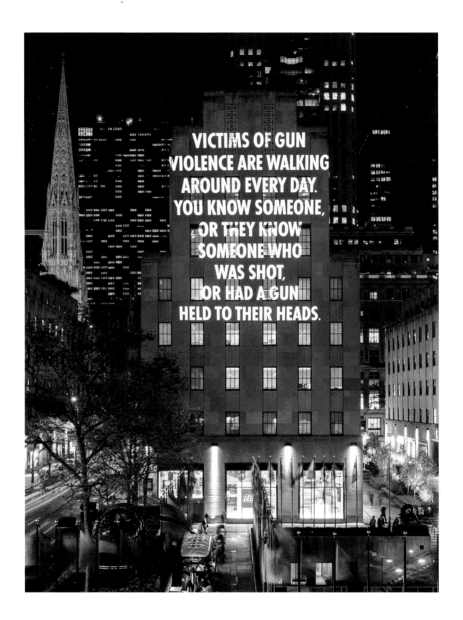

AI WEIWEI
BORN 1957, BEIJING, CHINA

Lives and works in multiple locations including Beijing, China;
Berlin, Germany; Cambridge, UK; and Lisbon, Portugal

Ai Weiwei has never shied away from difficult subjects. His art and
activism respond to real-life events and injustices. 'As an artist
I have to relate to humanity's struggles ... I never separate those
situations from my art.' Ai's work assumes various forms, including
sculpture, installation, film and photography. He also undertakes
investigations and enquiries, publishing his findings and criticism
using blogs and social media. His forthright and rebellious approach,
coupled with his desire to uncover corruption and human rights
abuses, has led to multiple run-ins with the Chinese authorities.
In 2011, Ai was secretly detained for 81 days without any formal
charges.

Ai Weiwei's art is collaborative in spirit. In *Remembering*, a
poignant installation from 2009, Ai presented 9,000 school
backpacks on the exterior of Munich's Haus der Kunst to represent
the estimated number of children lost in the Sichuan earthquake
of 12 May 2008. The authorities had downplayed the true number
of victims to conceal a widespread failure to adhere to building
regulations for schools.

Ai Weiwei
Dropping a Han Dynasty Urn, 1995
Lambda print
Each print 180 x 162 cm
(70⅞ x 63⅞ in.)

During the 1990s, Ai
acquired a group of
historic vases with the
intention of making
several new works.
This work captures the
artist in the process
of dropping a genuine
2,000-year-old Han
Dynasty vase. The camera
didn't capture the action
adequately on the first
attempt and so a second
vase was needed to
perfect the sequence.

In 2010, Ai presented *Sunflower Seeds* (2010) in the Turbine Hall of Tate Modern in London. The work comprised 100 million porcelain seeds, hand-painted by a community of craftspeople in Jingdezhen, China.

Ai Weiwei
Colored Vases, 2007
Neolithic vases and
industrial paint
Various dimensions

The act of dipping
Neolithic vases from
5,000–3,000 BCE into
industrial vats of paint
could be considered
destructive. However,
in Ai's hands the gesture
spins a web of ideas
concerning history and
modernity, originality
and cultural value. Ai
takes a characteristically
open position, offering
suggestions but keeping
an open mind on
conclusions.

KEY FACTS

Ai Weiwei collaborated with the Swiss architects Herzog & de Meuron, working as artistic consultant on their scheme for the Beijing National Stadium for the 2008 Olympic Games.

In 2012, the documentary *Ai Weiwei: Never Sorry* was released. Directed by the American filmmaker Alison Klayman, the film won a special prize at the 2012 Sundance Festival in Utah, USA.

KEY WORKS

Han Jar Overpainted with Coca-Cola Logo, 1995, The Metropolitan Museum, New York, USA

Remembering, 2009, installation at Haus der Kunst, Munich, Germany

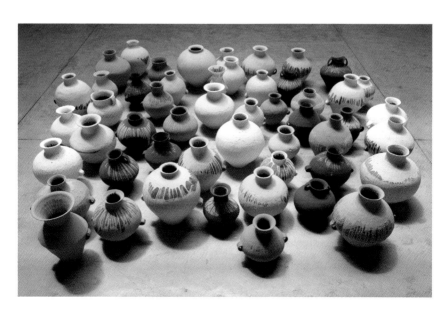

THEASTER GATES
BORN 1973, CHICAGO, USA

Lives and works in Chicago, USA

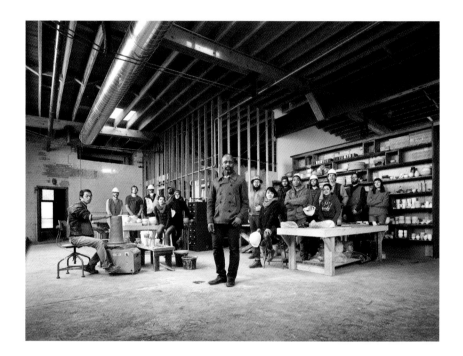

After gaining degrees in art, religious studies and urban planning,
Theaster Gates commenced his artistic career as a ceramicist:
'I think that studying clay helped me understand that ugly things,
muddy things, or things that are unformed are just waiting for
the right set of hands.' Gates continues to work in the medium
but also nurtures an ambitious and transformative social practice.
Both aspects of his work reflect on politics, race and cultural heritage.
Gates reflects deeply on his role as an artist: 'I'm still wrestling with
the relationship between the symbolic work that ends up on a wall
and the pragmatic work that kind of changes lives or creates new
education options or creates new employment pathways.'

Gates has made a significant impact in his home city. Operating in Chicago's South Side, where crime rates are high and investment opportunities scarce, he bought up abandoned properties, employing members of the community to work with him to transform empty dwellings into community hubs. Gates sells artworks made using discarded materials from each property to fund the next scheme, creating a sustainable cycle of repurposing and reinvestment. *Archive House* accommodates 14,000 books sourced from a closing-down bookstore. Complete with its own Soul Food Kitchen, this local library is a space for the community to read, meet, talk and eat. Another development, *Listening Room*, features some 8,000 records salvaged from an out-of-business vinyl store. The aesthetic of Gates's interiors is handcrafted and utilitarian. Salvaged materials are transformed into simple, elegant and useful objects. Gates has also turned his attention to improving living standards, devising a public housing project which provides accommodation for families on reduced incomes and emerging artists.

Theater Gates
*Dorchester Projects,
Chicago*, 2012

The title refers to South Dorchester Avenue, the place in the South Side of Chicago where Gates purchased his first property for renovation. Gates often incorporates an archive into his schemes. These libraries or collections, which can be augmented over time, acknowledge and invest in black cultural forms and provide an important source of reference for the community.

KEY FACTS

Theater Gates is a Professor in the Department of Visual Arts at the University of Chicago.

In 2022, Gates designed the Serpentine Pavilion for the grounds of Serpentine Gallery, London. Supported by Adjaye Associates, Gates created *Black Chapel*, which took its inspiration from chapel architectures and firing kilns.

KEY WORKS

Civil Tapestry 4, 2011, Tate, London, UK
Raising Goliath, 2012, White Cube, London

GUERRILLA GIRLS
FOUNDED 1985, NEW YORK CITY, USA

Active worldwide

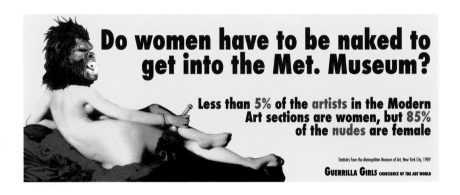

The Guerrilla Girls are an anonymous group of artist activists who campaign for equality around gender and race. They describe themselves as 'feminist masked avengers in the tradition of anonymous do-gooders like Robin Hood, Wonder Woman and Batman'. Wearing gorilla masks and working under the pseudonyms of famous women artists, these undercover agents use wit, humour and hard data to effect change. They often employ tactics of humiliation to shame art galleries, collections and other cultural institutions into action.

The Guerrilla Girls first mobilized in 1984 in direct response to a major exhibition at the Museum of Modern Art in New York titled 'An International Survey of Recent Painting & Sculpture'. Of 169 artists represented in the show, only thirteen were women, none of whom were from ethnically diverse backgrounds. Protests took place outside of the gallery. However, the group quickly realized that they needed to diversify their activity to mobilize a younger generation. They began flyposting across downtown Manhattan to

campaign against the discriminatory practices of the New York art scene. Gradually they expanded their campaign to tackle a global range of issues, developing eye-catching poster, billboard and sticker campaigns emblazoned with fact-driven headlines that were hard to dispute. Perhaps their most famous poster campaign of 1989 was sparked by their nudity or 'weenie' count in the collection displays of the Metropolitan Museum of Art, New York, which revealed shocking disparities.

Increasingly, the Guerrilla Girls work directly with galleries and art institutions to present exhibitions and stage interventions. With almost forty years of campaigning and activism behind them, the Guerrilla Girls have contributed significantly to public debates concerning cultural diversity and inclusion, prompting many improvements to exhibition programming and collection development.

Guerrilla Girls
Do women have to be naked to get into the Met. Museum?, 1989
Off-set print on paper
28 x 71 cm (11⅛ x 28 in.)

The Guerrilla Girls combine hard facts with strong typographic designs to create impactful posters and prints. This famous campaign featured a reproduction of *La Grande Odalisque* (1814) by Jean-Auguste-Dominique Ingres. The head of this reclining female figure is replaced with a gorilla mask to challenge stereotypes of female beauty and deflect the male gaze.

KEY FACTS

In 2005, the Guerrilla Girls staged a poster campaign at the 51st Venice Biennale titled *Welcome to the Feminist Biennale*. Their intervention included an analysis of diversity across the Biennale's history and within the city's art collections.

In 2020 the Guerrilla Girls published the book *Guerrilla Girls: The Art of Behaving Badly*, which documented thirty-five years of activism.

KEY WORKS

When Racism & Sexism are No Longer Fashionable, What Will Your Art Collection Be Worth?, 1989, National Gallery of Art, Washington DC, USA

Dear Art Collector Billionaire, 2015, Pennsylvania Academy of the Fine Arts, Pennsylvania, USA

OTOBONG NKANGA
BORN 1974, KANO, NIGERIA
Lives and works in Antwerp, Belgium

Otobong Nkanga's interest in art and environmental issues began at an early age. As a child growing up in Lagos, Nigeria, she would collect minerals and use glistening hunks of mica to make drawings on the pavements. Nkanga moved to Paris with her family as a teenager, going on to study at various art institutions in Nigeria and Europe. She has since developed a substantial artistic practice which explores the complex relationship between humans and the natural environment. Her work expresses an overriding desire to protect the environment and to encourage the responsible use of its precious resources.

Nkanga intends for her art to forge connections rather than to create boundaries or divisions. She uses a wide range of materials and techniques, from sculpture and tapestry to performance, photography and video. Installation provides a useful vehicle for her to establish links across media. Nkanga's poetic accumulations fuse bodies, terrains and natural resources to shed light on complex geopolitical issues, including the global trade in raw materials and the irreversible environmental scarring caused by relentless extractivism.

Nkanga takes inspiration from the idea of 'material emotionality', believing that all matter can hold memories and feelings. She seeks to empower her materials to communicate the impact of violent environmental exploitation. Equally evident in Nkanga's work is a desire to shift between the micro and the macro, between local and global concerns. For Nkanga, everything is connected and everyone is implicated.

Otobong Nkanga
Revelations, 2020
Woven textile with photography (yarns: cotton, viscose, linen, arnica, techno, elirex, polyester, sidero; 18 photographic images on forex)
Edition of 5 plus 1 AP
240 x 180 cm
(94½ x 70⅞ in.)

Influenced by craftspeople in West Africa and Belgium, Nkanga has produced numerous tapestries, interweaving her core concerns with recurrent visual motifs. Headless figures often appear in Nkanga's work. In this piece, a solitary figure occupies a scarred mineral landscape. A molecular structure conceals the head and shoulders, introducing global implications through the inclusion of photographic imagery.

KEY FACTS
In 2015, Otobong Nkanga won the prestigious Yanghyun Prize, which is designed to support and celebrate the work of mid-career artists.

Nkanga was artist in residence at Gropius Bau in Berlin, Germany, in 2019. The residency led to a major solo exhibition titled 'There's No Such Thing as Solid Ground'.

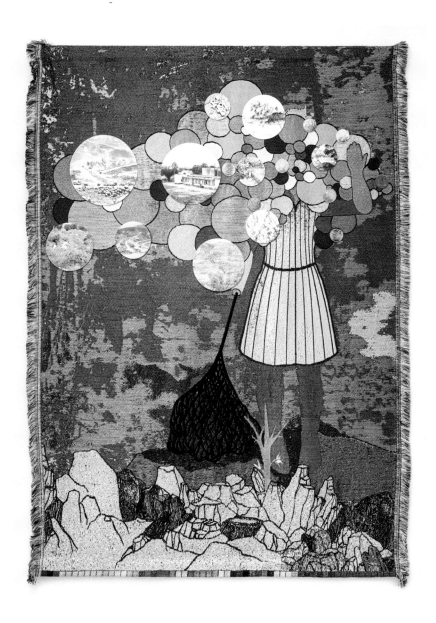

KEY WORKS

In Pursuit of Bling: Coalition, 2014, Lumen Travo Gallery,
 Amsterdam, Netherlands
The Weight of Scars, 2015, Lumen Travo Gallery, Amsterdam,
 Netherlands

DORIS SALCEDO
BORN 1958, BOGOTÁ, COLOMBIA

Lives and works in Bogotá, Colombia

Doris Salcedo
Untitled, 2003
1,550 wooden chairs,
10 x 6.1 x 6.1 m
(32 ft 10⅛ in. x 20 ft ¼ in.
x 20 ft ¼ in.)
Site specific installation,
8th International Istanbul
Biennial, Istanbul, 2003

This powerful installation
recalled the terrifying
accumulations of
personal objects taken
from the victims at
Auschwitz. It also pointed
to many other injustices
and conflicts, as Salcedo
has explained: 'I'm
reminded of mass graves.
Of anonymous victims.
I think of both chaos and
absence, two effects of
wartime violence.'

Doris Salcedo uses found materials such as chairs, shirts, shoes and human hair to tell poignant stories of violence, trauma and absence. She often fills domestic objects such as cupboards and wardrobes with concrete to preserve and embed human traces and to suggest acts of brutality and engulfment. Her work references the volatile social and political situation in her home country of Colombia, where 'disappearance' is a frequent strategy used by the military. Having experienced the 'disappearance' of members of her own family, Salcedo uses her direct knowledge of a particular context to reflect upon universal experiences of oppression and loss: 'What I'm trying to get out of these pieces is that element that is common in all of us.'

Salcedo has gradually expanded her practice to explore the potential of site-specific installations. An invitation to make a work for the 8th International Istanbul Biennial in 2003 prompted her to consider an unremarkable space between two buildings in the centre of the city. Salcedo filled the void with 1,550 wooden chairs. Stacked randomly on top of one another, these secondhand seats towered almost three storeys high. This precarious accumulation was impossible to ignore. It acted as a powerful monument to absence and loss, satisfying Salcedo's desire to make 'a topography of war, one that was embedded, really *inscribed* in everyday life'. In 2007, Salcedo created *Shibboleth* for Tate Modern's vast Turbine Hall. Rather than fill an empty space, this time Salcedo opened up a deep chasm in the floor. Measuring over 167 metres long, this rupture created an actual division between gallery visitors, prompting them to reflect on 'the experience of immigrants, the experience of segregation, the experience of racial hatred'.

―――――――
KEY FACTS

In 2016, Doris Salcedo won the Nasher Sculpture Center's inaugural Nasher Prize for Sculpture.

Salcedo's work is represented in collections all over the world, including the Museum of Modern Art, New York, and the National Gallery of Canada, Ottawa.

―――――――
KEY WORKS

Shibboleth, from the Unilever Series, 2007–8, installation, Tate Modern, London, UK

A Flor de Piel, 2013, Harvard Art Museums, Cambridge, Massachusetts, USA

1980: Larry Gagosian launches Gagosian Gallery in Los Angeles.

1984: The Havana Biennial is founded in Havana, Cuba.

The Guerrilla Girls stage their first protest in response to the exhibition 'An International Survey of Recent Painting & Sculpture' at the Museum of Modern Art, New York.

1986: The artist Joseph Beuys dies at the age of 64.

1987: Founded and edited by Rasheed Araeen, the art journal *Third Text* is launched to explore global developments in contemporary art.

1988: A major retrospective exhibition of Robert Mapplethorpe's photography opens at the Institute of Contemporary Arts, Philadelphia, sparking a ferocious debate around obscenity laws and the use of public funding for the arts.

Jean-Michel Basquiat dies from a heroin overdose at the age of 27.

1989: 'The Other Story' exhibition takes place at the Hayward Gallery, London. Curated by Rasheed Araeen, the exhibition presents the work of 'Asian, African and Caribbean artists in post-war Britain'.

The 'Magiciens de la Terre' exhibition launches at the Centre Georges Pompidou in Paris. Curated by Jean-Hubert Martin, the show traces ethnographic influences on contemporary art.

1991: *Frieze*, 'a leading magazine of art and culture', launches.

Charles Saatchi commissions Damien Hirst's work *The Physical Impossibility of Death in the Mind of Someone Living*. The work comprises a dead shark suspended in a glass display case filled with formaldehyde.

1992: The commercial gallery Hauser & Wirth is founded in Zürich by Iwan Wirth, Manuela Wirth and Ursula Hauser.

For the first time, African artists are represented in the exhibition 'documenta'.

1993: Jay Jopling launches White Cube, a commercial art gallery in London.

Rachel Whiteread is the first woman to win the Turner Prize, for *House* (1993), a cast of a London terraced house.

The Sharjah Biennial is founded in Sharjah, United Arab Emirates.

1995: The Museum of Contemporary Art Tokyo opens.

1996: The Shanghai Biennale launches; it is the first international biennial to take place in mainland China.

1997: The major touring exhibition 'Cities on the Move' launches at the Vienna Secession in Austria. Curated by Hans Ulrich Obrist and Hou Hanru, this ambitious show assesses the impact of urbanism on East Asian culture and tours globally until 1999.

The Guggenheim Museum Bilbao, Frank Gehry's futuristic architectural masterpiece, opens to the public.

1999: The Fourth Plinth commissioning scheme is established in London, enabling a selected artist to present a work on the unoccupied fourth plinth in Trafalgar Square.

2000: Tate Modern opens to the public in London and attracts 5,250,000 visitors in its first year.

2001: Takashi Murakami founds his production company, Kaikai Kiki Co. Ltd.

Martin Creed wins the Turner Prize with *Work No. 227, The lights going on and off* (2000).

2002: Okwui Enwezor is appointed curator and director of 'documenta 11'.

The Félix Gonzalez-Torres Foundation is established to 'foster an appreciation for the work of Félix González-Torres among the general public, scholars, and art historians'.

Art Basel Miami Beach takes place for the first time in Florida, USA, following the success of the original Art Basel fair, which was established in 1970.

The Palais de Tokyo museum of contemporary art opens in Paris, France.

2003: The first Frieze Art Fair takes place in London.

Olafur Eliasson's major installation *The Weather Project* (2003) fills the vast Turbine Hall in Tate Modern, London with a gigantic sun.

2005: The Museum of Contemporary Art Shanghai opens.

2006: Anish Kapoor's highly reflective stainless steel sculpture *Cloud Gate* (2006) is unveiled in Millennium Park, Chicago.

2007: The major touring exhibition 'Wack: Art and the Feminist Revolution' opens at the Museum of Contemporary Art, Los Angeles.

2010: Louise Bourgeois dies at the age of 98.

The social media platform Instagram launches, providing a powerful new marketing tool for artists, museums and dealers.

2011: Ai Weiwei is secretly detained for 81 days without any formal charges, provoking international criticism.

The Hepworth Wakefield opens in Wakefield, UK. Designed by David Chipperfield, this major museum is named after the sculptor Barbara Hepworth, who was born and raised in the city.

2012: Two members of the Russian feminist collective Pussy Riot are imprisoned for two years following the release of their music video *Punk Prayer – Mother of God, Chase Putin Away!*

2013: Okwui Enwezor is appointed curator of the 2015 Venice Biennale, the first African-born curator in the Biennale's history.

The retrospective exhibition, 'Yayoi Kusama: Infinite Obsession', launches at MALBA, Buenos Aires, before touring South and Central America. The show attracts over two million visitors.

The first edition of Art Basel Hong Kong takes place.

2014: Georgia O'Keeffe's painting *Jimson Weed / White Flower No. 1* (1932) sells for $44.4 million, breaking the record for the highest price paid for an artwork by a woman.

2015: The first Nasher Prize for Sculpture is awarded to Doris Salcedo.

The Swiss curator Hans Ulrich Obrist publishes the book *Ways of Curating*.

2017: The Lagos Biennial for Contemporary Art is founded in Lagos, Nigeria.

Lubaina Himid is the first black woman to win the Turner Prize. She is also the oldest winner.

Zeitz Museum of Contemporary Art Africa opens in a former grain silo in Cape Town and becomes the world's biggest museum dedicated to contemporary art from Africa.

The #MeToo movement against sexual harassment and abuse originates on social media.

2018: Museum of African Contemporary Art Al Maaden opens in Marrakech, Morocco.

Banksy's painting *Girl with Balloon* descends through the jaws of a shredder moments after its auction sale at Sotheby's, London.

2019: An edition of Jeff Koons's *Rabbit* (1986) sells for $91.1 million, breaking the record for the highest price paid for an artwork by a living artist.

Maurizio Cattelan's work *Comedian* (2019), comprising a banana stuck to the wall with duct-tape, goes on sale at the Art Basel Miami Beach art fair. Made in an edition of three, the work sells out on the first day.

Okwui Enwezor dies at the age of 55.

2020: In the wake of the killing of George Floyd in Minneapolis, USA, Black Lives Matter protests take place globally, prompting many actions and strategies to tackle racial discrimination and unconscious bias.

The Covid-19 pandemic causes the temporary physical closure of many museums, galleries and contemporary art events, leading to the loss of many jobs. Venues increasingly turn to digital methods to share programmes and collections.

2021: Christie's makes auctioneering history by selling a non-fungible token (NFT) by the digital artist Beeple for $69 million.

2022: Sonia Boyce and Simone Leigh become the first black women to represent the United Kingdom and the United States respectively at the Venice Biennale. Both artists scoop the prestigious Golden Lion prize.

KNOW YOUR ARTSPEAK

Abstraction: An approach to art that does not seek to represent objects in the real world but instead uses shapes, colours, textures or forms as its starting point.

Activist Art: A form of art that involves direct engagement with social or political issues with the aim of bringing about positive change.

Appropriation: Incorporating an image or object from another cultural source with minimal adaptation, often seen as offensive if the source culture is not acknowledged.

Biennial: A major exhibition of art hosted in a particular location every two years.

Co-curation: A process whereby an artist or institution invites other individuals and communities to collaborate on the curation of an exhibition or project. Co-production and co-creation are often used to describe similar activities.

Conceptual Art: A movement that first emerged during the late 1960s. Conceptual artists use ideas and theoretical concepts as the source material for their work. Moving beyond traditional skills and the production of finished objects, Conceptual Art can assume many forms and outcomes.

Curator: Originally the person employed to care for a collection. Nowadays the term is widely used to refer to a range of roles involving the organization and interpretation of cultural forms, including exhibitions.

Digital Art: Art made using digital technology or presented in the digital realm.

documenta: Founded in 1955, this major international exhibition of contemporary art takes place in Kassel, Germany, every five years.

Endurance Art: A form of Performance Art involving the extreme physical or mental endurance of the artist. These performances can involve pain or social isolation and can take place over a long period of time. See also: *Performance Art.*

Feminist Art: A category of art emerging in the late 1960s and early 1970s. Drawing on feminist theory and ideas, feminist artists use a variety of materials and perspectives to challenge gender stereotypes and to fight inequality in the art world and across wider society.

History painting: A genre of painting involving the depiction of historical, mythological or religious scenes. Often large in scale, history paintings were considered the highest form of art for many centuries.

Installation art: A work of art occupying or responding to a particular space. Installation art rose to prominence during the 1960s and remains a popular art form within contemporary practice. Installations can take many forms and often feature a wide range of materials. The active engagement of the audience is an important feature.

Interactive art: A type of art that requires direct public interaction to harness its full potential.

Land Art: An international art movement that flourished in the 1960s and 1970s and involves a direct engagement with landscapes and sites. Land Art, which is also known as Earth Art,

often incorporates processes from *Conceptual Art* and *Performance Art*.

Live Art: A broad term used to describe a wide range of practices involving live performances, events and actions.

Minimalism: An approach that first emerged in America in the 1960s and involved the extreme reduction of art to simple geometrical forms, often presented as repeated units. See also: *Abstraction.*

Mixed media: The use of more than one medium or material within the same artwork.

Modernism : Beginning in the late nineteenth century, Modernism involved breaking away from traditional methods to pursue new ways of representing the modern world. Spanning art, architecture, music and literature, Modernist ideas influenced successive generations of practitioners well into the twentieth century.

Neo-Expressionism: An expressive and gestural approach to painting which emerged during the 1980s. Neo-Expressionism was an international phenomenon with a particularly strong presence in Germany.

Neo-Pop: A movement in art developing in the 1980s and 1990s and involving a renewed interest in Pop art and its appropriation of popular and kitsch cultural forms.

New media: A wide-ranging term used to describe art made using digital technologies. See also: *Digital Art.*

Performance Art: A time-based form of art involving actions undertaken by the artist or by other people. Performance Art often involves live presentations in front of an audience, with photography and film often used to document the action. Although the specific term only came into common use during the 1970s, a performative spirit can be discerned in much twentieth-century art practice.

Postmodernism: Postmodernism emerged during the 1960s, when artists began to challenge the unified and streamlined visions of Modernism in favour of a plurality of ideas and approaches, including critique and irony.

Retrospective: A type of exhibition that surveys the entirety of an artist's oeuvre. A mid-career retrospective surveys the work to date of a younger artist with an established practice.

Site-specific art: Art made for and in a particular location, often outdoors. The work tends to respond to the features or context of the chosen site.

Socially engaged practice: A participatory art form involving individuals and communities coming together to co-create and interact with the work.

Sound art: A work of art involving sound as its subject and its material. Sound art can feature pre-recorded or live content, or a mixture of the two.

Time-based media: An umbrella term to describe art forms that unfold in time, for example, film, performance and digital art.

Triennial: A major exhibition of art hosted in a particular location every three years.

SOME THOUGHTS ON LOOKING

The contemporary art world is a rapidly changing scene. Just when you think you have got your head around the major players, a whole new generation of artists, curators and galleries springs up! It is not necessary, nor is it possible, to know every artist and organization. It can be helpful, however, to equip yourself with some simple strategies for approaching contemporary art so that you can tackle any new development heading your way!

Make a start
Take a minute to make a quick assessment of the artwork. What is it? View the work from different angles if you can. Consider the size, colour and materials used and think about how the work has been presented. If you are exploring a film or performance work, get comfortable and enjoy the action. Free your mind of preconceptions and try to take in as much information as you can. What are your immediate thoughts and reactions? Try to describe the work to a friend in a couple of sentences, or, if you are on your own, think it through for yourself.

Delve deeper
Spend more time with the artwork and ask questions. For example, how might the work have been made? How does the choice of colour, size or material affect your reading of the work? What's going on: is there a story, or a text to read? What is the artist trying to tell us? How does the work make you feel?

Think outside the box
Check out the label. When was the work made and by whom? Does the title add anything? Why do you think the artist made this work? Why did they take this approach? Does the work point to external events such as politics, social issues or the environment? Is there any contextual information in the gallery? Does this change or reinforce your thinking?

Draw your own conclusions
What do you think of the artwork now? Think critically and take a position. Remember, you don't have to like everything, but try to offer a reason for your view if you don't. If the artwork moves you, enjoy spending more time with it! You could take a photo of the work or note down the details in your art diary so that you can find out more about the artwork or the artist later.

WHERE TO FIND CONTEMPORARY ART

Go to a listings website such as www.artrabbit.com or www.artforum.com/guide to discover events in your area. A special art map is often produced for larger art centres.

Public galleries
Public galleries present a changing programme of exhibitions. Some also have house collections, which are made available through changing displays and digital access. Public galleries have made huge leaps in recent years to make their spaces and collections more accessible for everyone. They have a duty to interpret their exhibits in relevant ways, so you will often find helpful labels and wall texts, films, activities and resource hubs. Temporary exhibitions often come with an admission fee. Having concession status or being a member of an art pass scheme can really help to reduce costs. You could also become a Friend of a

gallery you visit regularly – it's a great way to get involved and enjoy special benefits and events!

Commercial galleries

Although visiting a commercial gallery tends to be free of charge, it can be a daunting experience. Major commercial galleries in art centres can be slick affairs: huge doors leading to legions of crisp white cube spaces filled with the latest art. Smaller enterprises can be off the beaten track, and you might have to ring the doorbell. Don't be put off! Stand tall, sign up for the mailing list, grab a press release and list of works, and have a look around. Visiting a commercial gallery is a great way of seeing a new body of work by an artist before it sells, and if you are in a major art centre, you can visit lots of galleries in the same district. Commercial galleries tend to programme solo shows of work by the artists they represent. Group shows are also a regular feature: some of the larger, wealthier galleries have staged huge international surveys in recent years, accompanied by substantial scholarly publications. All commercial ventures are driven by the market, thus galleries come and go, and some become 'hotter' than others, depending on their current roster of artists.

Art fairs

The primary purpose of an art fair is to sell art. Commercial galleries apply to have a stall at an international art fair, jostling for the best, most visible locations. As space hire costs are so high, art fairs tend to be dominated by major players. Art works are presented with private collectors in mind, hence a strong emphasis on painting, wall-based work and smaller sculptures. Of course, these choices are also dictated by limited display space. Visiting an art

fair is a great way of seeing a vast volume of international art in one day. Art fairs also attract high-profile speakers for their related events programmes, so be sure to book your place well in advance. Visiting an art fair can be a frenetic and exhausting experience, so pace yourself.

Biennials

Visiting a biennial can be an excellent opportunity to see a vast range of contemporary art and to explore a new context. Biennials often have a central exhibition located in a particular venue or group of venues, with many other artworks and fringe events presented in public spaces. Artworks are sited in unusual places, offering a rare opportunity for visitors to explore sites and buildings not commonly on the tourist track. Be mindful that some fringe events and live performances take place in the early weeks, so check the schedules carefully. If visiting a biennial in real life is not possible, you can always enjoy it from the comfort of your armchair by following the event via the website and social media channels!

Emerging scenes

There are lots of ways to support the artists working in your area. Larger towns and cities have studio spaces and artist-led initiatives where you can attend special 'open studio' events and openings for curated shows. Follow your local studio space on social media for details of future events. You could also visit the degree shows at the art schools and universities near you to get a sense of new talent, and don't forget smaller commercial ventures outside of major art centres. You might even find an opportunity to buy a work of art from one of these contexts. Starting your own collection can be more affordable than you think.

Public spaces

As this book testifies, art can be sited anywhere! You can find it on a street corner, in a public plaza, on a bus, in a station, on a billboard, in the desert, on a boat, in a garden, in a forest, in the sea, in a puddle, on television, online, in outer space, or underneath the ground. Indeed, once you start looking out for it, contemporary art seems to follow you wherever you go!

FIND OUT MORE

Websites & social media

There are many brilliant websites dedicated to contemporary art. Just entering an artist's name into a search engine can reveal a world of useful content. Most major artists have substantial websites offering valuable primary resources. Public museums and galleries share excellent online content about their collections and programmes, including a range of films and educational material. Commercial galleries also have excellent websites and hold extensive resources on their represented artists, including biographies, interviews and films. Social media is a powerful communication tool for the contemporary art world. Follow your favourite artists and galleries on social media today to gain the latest insights and links.

https://artsandculture.google.com/
www.guggenheim.org
www.henitalks.com
www.labiennale.org
www.moma.org
www.sharjahart.org
www.tate.org.uk
www.whitney.org
www.zeitzmocaa.museum

Journals & periodicals

There are many useful journals and periodicals specializing in contemporary art. Some of these require a subscription, however they often have an option to view several articles per month for free. It is also worth following the social media accounts of these publications for the latest art world news and gossip.

www.artforum.com
www.artinamericamagazine.com
www.artnews.com
www.theartnewspaper.com
www.flash---art.com
www.frieze.com
www.ocula.com
www.studiointernational.com
www.thirdtext.org
www.whitehotmagazine.com

Books

Here are some suggestions for further reading. There are, of course, many other titles out there focusing on specific artists and themes. So, once you have honed your interests, support your local library or bookshop if you can, and don't forget the other titles in the *Art Essentials* series!

An, Kyung and Jessica Cerasi, *Who's Afraid of Contemporary Art?* (Thames & Hudson, London and New York, 2017)

Bishop, Claire, *Artificial Hells: Participatory Art and the Politics of Spectatorship* (Verso, London, 2012)

De Wachter, Ellen Mara, *Co-Art: Artists on Creative Collaboration* (Phaidon, London, 2017)

Diament, Robert and Russell Tovey, *Talk Art: Everything You Wanted to Know About Contemporary Art But were Afraid to Ask* (Ilex Press, London, 2021)

Documents of Contemporary Art series (Whitechapel Art Gallery & MIT Press, London and Cambridge, MA)

George, Adrian, *The Curator's Handbook* (Thames & Hudson, London, 2015)

Godfrey, Tony, *The Story of Contemporary Art* (Thames & Hudson, London and New York, 2020)

Hessel, Katy, *The Story of Art Without Men* (Hutchinson Heinemann, London, 2022)

Jiang, Jiehong, *The Art of Contemporary China* (Thames & Hudson, London and New York, 2021)

Kasfir, Sidney Littlefield, *Contemporary African Art* (Thames & Hudson, London and New York, 2020)

Obrist, Hans Ulrich, *Ways of Curating* (Penguin, London, 2015)

Okeke-Agulu, Chika and Salah M Hassan (eds), *Nka Journal of Contemporary African Art* (Vol. 2021, issue 48) 'Okwui Enwezor, the Art of Curating' (Duke University Press, Durham, NC, 2021)

Perry, Grayson, *Playing to the Gallery: Helping Contemporary Art in its Struggle to be Understood* (Penguin, London, 2016)

Poupeye, Veerle, *Caribbean Art* (Thames & Hudson, London and New York, 2022)

Procter, Alice, *The Whole Picture: The colonial story of the art in our museums & why we need to talk about it* (Ilex Press, London, 2020)

Stallabrass, Julian, *Contemporary Art: A Very Short Introduction* (Oxford University Press, Oxford, 2006)

Stiles, Kristine and Peter Selz (eds), *Theories and Documents of Contemporary Art: A Sourcebook of Artists' Writings* (University of California Press, Berkeley, CA, 1998)

Thornton, Sarah, *Seven Days in the Art World* (Granta Books, London, 2009)

Williams, Gilda, *How to Write About Contemporary Art* (Thames & Hudson, London, 2014)

Wood, Catherine, *Performance in Contemporary Art* (Tate Publishing, London, 2022)

INDEX OF ARTISTS

Main entries are in **bold**, illustrations
are in *italics*.
Excludes 'Key Artists' listings.

PICTURE ACKNOWLEDGEMENTS

2 Victoria Harbour, Hong Kong. Photo @harimaolee. © KAWS; **4** 8th International Istanbul Biennial, Istanbul, 2003. Courtesy White Cube. © Doris Salcedo; **8** Gagosian Gallery. © 2007 Taskashi Murakami/Kaikai Kiki Co., Ltd. All Rights Reserved; **10** © Gerhard Richter; **11** British Council Collection, London. Rasheed Araeen care of Grosvenor Gallery; **12** Pilane Heritage Museum, Klövedal, Sweden. Courtesy Galerie Lelong & Co. Photo Peter Lenbby © Plensa Studio Barcelona. © Jaume Plensa; **13** Senga Nengudi and Maren Hassinger at Pearl C. Woods Gallery, Los Angeles, 1978. Photo Harmon Outlaw. Courtesy the artist, Sprüth Magers and Thomas Erben Gallery; **14** Castellane Gallery, New York, 1965. Courtesy Ota Fine Arts and Victoria Miro. © Yayoi Kusama; **15** Tate Gallery, London. © Georg Baselitz 2023; **16** © Jeff Koons; **17** The Museum of Modern Art, New York. Courtesy the Estate of David Wojnarowicz and P·P·O·W, New York; **18** Photo Carlos Dominique/Alamy Stock Photo. © The Easton Foundation/VAGA at ARS, NY and DACS, London 2023; **19** Solomon R. Guggenheim Museum, New York. © Vanessa Beecroft 2023; **20** Courtesy Kimsooja Studio; **21** Walker Art Gallery, National Museums, Liverpool. National Museums Liverpool/Bridgeman Images. © Peter Doig. All Rights Reserved, DACS 2023; **22** Courtesy Marian Goodman Gallery, New York. Messager © ADAGP, Paris and DACS, London 2023; **24** Photo Ken Adlard. Courtesy Lisson Gallery. © Ryan Gander; **26** Victoria Harbour, Hong Kong. Photo @harimaolee. © KAWS; **28–9** Photo John Berens. Courtesy 303 Gallery, New York, KÖNIG GALERIE, Berlin, and Galleri Nicolai Wallner, Copenhagen. © Jeppe Hein; **31 (above)** Art Institute Chicago. The Art Institute of Chicago/Art Resource, NY/Scala, Florence. © Bruce Nauman/Artists Rights Society (ARS), New York and DACS, London 2023; **31 (below)** Courtesy the artist, Thomas Dane Gallery and Marian Goodman Gallery. © Steve McQueen; **32** Courtesy the artist, Luhring Augustine, New York and Stephen Friedman Gallery, London. © Tom Friedman; **33** Courtesy the artist and Sadie Coles HQ, London. © Sarah Lucas; **35** Photo Zeno Zotti. Courtesy Maurizio Cattelan's Archive; **36** Hayward Gallery, London. Nathaniel Noir/Alamy Stock Photo. Höller © DACS 2023; **38** Courtesy Marian Goodman Gallery, New York. Messager © ADAGP, Paris and DACS, London 2023; **41** Gagosian Gallery. © 2007 Taskashi Murakami/Kaikai Kiki Co., Ltd. All Rights Reserved; **42** Nevada Museum of Art, Las Vegas. Courtesy Art Production Fund and Nevada Museum of Art, Reno. Photo Gianfranco Gorgoni. © Ugo Rondinone; **43** Courtesy the artist and Sadie Coles HQ, London. Photo Studio Rondinone. © Ugo Rondinone; **45** Courtesy Carlos/Ishikawa, Stigter Van Doesburg and Helsinki Contemporary; **46** Photo Ellen Page Wilson. Courtesy the artist and Gavin Brown's enterprise, New York. © Urs Fischer; **49** Tate Gallery, London. Purchased 1976. © Richard Long. All Rights Reserved, DACS 2023; **50** Courtesy the artist and Galerie Peter Kilchmann, Zurich; **51** Installed in 'Felix Gonzalez-Torres', Luhring Augustine Hetzler Gallery, Los Angeles, CA., 19 October–16 November 1991. Photo James Franklin. The Estate of Felix Gonzalez-Torres. © Felix Gonzalez-Torres; **52** Installation at Johnen Galerie, Berlin, Germany, 2004. © Martin Creed. All Rights Reserved, DACS/Artimage 2023; **53** Photo Sue Omerod; **54** Tate Modern, London. Photo Anders Sune Berg. Courtesy the artist; Andersen's Contemporary, Copenhagen; neugerriemschneider, Berlin; Tanya Bonakdar Gallery, New York/Los Angeles. © 2023 Olafur Eliasson; **55** Installation view, Duveen Galleries, Tate Britain, London, 2015. Photo Julian Abrams. The artist, Tanya Bonakdar Gallery, New York/Los Angeles and Galerie Isabella Bortolozzi, Berlin; **56** The Museum of Modern Art, New York. Nina and Gordon Bunshaft Fund. Courtesy the artist and Marian Goodman Gallery. © Gabriel Orozco; **57** Arts Council Collection, Southbank Centre, London. Partial gift of the artist and Maureen Paley, London. Purchased with the assistance of the Art Fund. © Wolfgang Tillmans, courtesy Maureen Paley, London; **59** Arts Council Collection, Southbank Centre, London. Purchased with the assistance of the Art Fund. Photo John McKenzie. Courtesy Parafin, London. © Alison Watt. All Rights Reserved, DACS 2023; **61** Photo Gautier Deblonde. Courtesy the artist and Galerie Gisela Capitain, Cologne; **62** Courtesy the artist and David Zwirner. © Michaël Borremans; **65** Photo Ellen Page Wilson. Courtesy the artist and Gavin Brown's enterprise, New York. © Urs Fischer; **67** Installation view, 'Roni Horn', Hauser & Wirth, New York, 27 Apr–29 Jul 2017. Photo Ron Amstutz. Courtesy the artist and Hauser & Wirth. © Roni Horn; **69** Commissioned for Hanjin Shipping The Box Project by National Museum of Modern and Contemporary Art. Photo Jeon Taegsu. Courtesy the artist and Victoria Miro. © Do Ho Suh; **70, 73** MACBA Collection, MACBA Foundation. © Bruce Nauman/Artists Rights Society (ARS), New York and DACS, London 2023; **74** Photo the Artist and Andrew Kreps Gallery, New York; **75** Installation view of 'Xu Zhen: In Just a Blink of an Eye', July 27–September 1, 2019 at MOCA Grand Avenue. Photo Myles Pettengill. The Museum of Contemporary Art. The artist and Perrotin; **76** Installation view, Cuxhaven, Germany. Photo Helmut Kunde, Strande, Germany. © Antony Gormley; **77** Courtesy the artist, Paragon, Contemporary Editions Ltd and Victoria Miro. © Grayson Perry; **78** The Museum of Modern Art, New York. Photo Marco Anelli. © Marina Abramovic. Courtesy Marina Abramovic Archives/DACS 2023; **79** Courtesy the artist and JTT, New York. © Juliana Huxtable; **80** Courtesy Hauser & Wirth; **82** Stevenson, Amsterdam/Cape Town/Johannesburg and Yancey Richardson, New York. © Zanele Muholi; **85** Courtesy Pest Control Office, Banksy, Love Is In The Bin, 2018; **87** Los Angeles County Museum of Art. Photo Joshua White Photography. Courtesy the artist, Victoria Miro, and David Zwirner. © Njideka Akunyili Crosby; **88** Eliza Douglas in Anne Imhof's *Faust*, 2017, German Pavilion, 57th Venice Biennial. Photo Nadine Fraczkowski, courtesy the artist and German Pavilion 2017; **91** Courtesy the artist and Chatterjee & Lal; **93** Arts Council Collection, Southbank Centre, London. Courtesy the artist; **94** Photo Carlos Dominique/Alamy Stock Photo. Bourgeois © The Easton Foundation/VAGA at ARS, NY and DACS, London 2023; **97** Photo Chris Winget. Courtesy the artist and Gladstone Gallery. © Matthew Barney; **98** Installation view, 'Nathalie Djurberg & Hans Berg: A Journey Through Mud and Confusion with Small Glimpses of Air', Moderna Museet, Stockholm, Sweden, 2018. Courtesy the artist and Tanya Bonakdar Gallery, New York/Los Angeles. Djurberg and Berg © DACS 2023; **99** Photo Uwe Walter, Berlin. Rauch © Courtesy Galerie EIGEN + ART, Leipzig/Berlin und Zwirner, New York/DACS 2023; **100** Photo © White Cube (Ben Westoby). © Christian Marclay; **101** Courtesy Christian Boltanski Studio and Marian Goodman Gallery. Boltanski © ADAGP, Paris and DACS, London 2023; **102** San Francisco Museum of Modern Art. Gift of Vicki and Kent Logan. Photo Ian Reeves. © Tracey Emin. All rights reserved, DACS 2023; **104**

Courtesy Regen Projects, Los Angeles; Lehmann Maupin, New York, Hong Kong, and Seoul; and Thomas Dane Gallery, London and Naples. © Catherine Opie; **105** The Museum of Modern Art, New York. Acquired through the generosity of Agnes Gund, the Contemporary Arts Council of The Museum of Modern Art, Carol and Morton Rapp, Marnie Pillsbury, the Contemporary Drawing and Print Associates, and Committee on Drawings and Prints Fund. Courtesy Sikkema Jenkins & Co., New York. © Kara Walker; **106** Courtesy Jon Key; **108** Courtesy Salon 94; **111** Courtesy Sophie Calle and Paula Cooper Gallery, New York. Calle © ADAGP, Paris and DACS, London 2023; **112** Tate Gallery, London. Photo Stephen Chung/Alamy Stock Photo. © Yinka Shonibare CBE. All Rights Reserved, DACS 2023; **115** © 2023 Shazhia Sikander; **116** Private Collection. Courtesy the artist and David Zwirner. © Luc Tuymans; **118** The Metropolitan Museum of Art, New York. Purchase, The Raymond and Beverly Sackler 21st Century Art Fund; Stephen and Nan Swid and Roy R. and Marie S. Neuberger Foundation Inc. Gifts; and Arthur Lejwa Fund, in honor of Jean Arp, 2008. Courtesy the artist and Jack Shainman Gallery, New York. © El Anatsui; **121** Installation view, Tate Britain, 'Altermodern. Tate Triennial 2009', London, UK, 2009. Photo Mike Bruce. Courtesy the artist and Hauser & Wirth. © Subodh Gupta; **122** Installation view of *The Great Acceleration*, Taipei Biennial 2014, Taipei, Taiwan, 2014. Collection of National Museum of Modern and Contemporary Art, Korea. Photo Taipei Fine Arts Museum; **123** The Metropolitan Museum of Art, New York. Gift of the artist, 2014. Photo © 2023 The Metropolitan Museum of Art/Art Resource/Scala, Florence; **124** The Metropolitan Museum of Art, New York. Purchase, Aleksandar Pesko Gift, 2016. Photo Joshua White/JWPictures. Courtesy the artist and Hauser & Wirth. © Mark Bradford; **125** Smithsonian American Art Museum, Washington, DC, Gift of the artist. Photo Smithsonian American Art Museum/Art Resource/Scala, Florence; **126** Art Gallery of Ontario. Purchase, with funds by exchange from Morey and Jennifer Chaplick and Women's Art Initiative, 2020. Photo © AGO. The Artist and Andrew Kreps Gallery, New York and Esther Schipper, Berlin. © Hito Steyerl; **127** Carnegie Museum of Art, Pittsburgh. Purchase, gift of Mr. and Mrs. Richard M. Scaife, by exchange. Courtesy the artist and Jack Shainman Gallery, New York. © Lynette Yiadom-Boakye; **128** The Museum of Modern Art, New York. Committee on Painting and Sculpture Funds. Courtesy the artist; Marian Goodman Gallery, New York, Paris; Esther Schipper, Berlin. © Pierre Huyghe; **131** The Metropolitan Museum of Art, New York. Purchase, The Raymond and Beverly Sackler 21st Century Art Fund; Stephen and Nan Swid and Roy R. and Marie S. Neuberger Foundation Inc. Gifts; and Arthur Lejwa Fund, in honor of Jean Arp, 2008. Courtesy the artist and Jack Shainman Gallery, New York. © El Anatsui; **132** 'Installative Textiles. From Medium to Place', Centro Andaluz de Arte Contemporáneo, Seville. Photo Pepe Morón. Courtesy Alison Jacques Gallery, London. Hicks © ADAGP, Paris and DACS, London 2023; **135** Courtesy Matthew Marks Gallery. © Simone Leigh; **136** Carnegie Museum of Art, Pittsburgh. Gift of Jeanne Greenberg Rohatyn and Nicolas Rohatyn and A. W. Mellon Acquisition Endowment Fund. Courtesy the artist and Marian Goodman Gallery. © Julie Mehretu; **139** The Museum of Modern Art, New York. Gift of the International Council of The Museum of Modern Art, Agnes, Gund Ronald S. and Jo Carole Lauder, and Sharon Percy Rockefeller, in honor of the 60th Anniversary of the International Council. Courtesy the artist and Victoria Miro. © Sarah Sze; **140** Ai Weiwei Studio; **142–3** Gallery of Modern Art, Queensland, Australia. Photo Eduardo Ortega. Courtesy the artist; New Museum, New York and Stephen Friedman Gallery, London. © Rivane Neuenschwander; **144** DZ BANK Art Collection at the Städel Museum, Frankfurt. Sierra © DACS 2023; **145** ANDY RAIN/EPA-EFE/Shutterstock. Courtesy Tania Bruguera and Tate Modern. Bruguera © ARS, NY and DACS, London 2023; **146** Installation view, Mexican Pavilion 53rd Venice Biennale, Making Worlds, 2009. The artist, Galerie Peter Kilchmann, Zurich, James Cohan, New York, and Labor, Mexico City; **147** Photo Stefan Altenburger Photography, Zürich. Courtesy the artist and Hauser & Wirth. © Rashid Johnson; **148** Courtesy the artist and Robert Mann Gallery; **149** The Metropolitan Museum of Art, New York. Courtesy the artist and Tanya Bonakdar Gallery, New York/Los Angeles. Photo Studio Tomás Saraceno, © 2012; **150** Courtesy the artist, Hauser & Wirth, New York, Regen Projects, Los Angeles, Thomas Dane Gallery, London and Chantal Crousel, Paris. © Glenn Ligon; **153** Used with her permission, from the Moments that Survive website of everytown.org. Rockefeller Center, New York, presented by Creative Time. Rockefeller Center, New York. Text testimony by Cheryl Stumbo. Photo Filip Wolak, Creative Time. © Jenny Holzer. ARS, NY and DACS, London 2023; **154, 155** Ai Weiwei Studio; **156** Photo Stephen Wilkes. © Theaster Gates; **158** © Guerrilla Girls; **161** Collections Henie Onstad Kunstsenter, Høvikodden, Bonnefantenmuseum, Maastricht. Hessel Museum of Art, Bard College, New York. Private collections in Netherland and USA. Photo Øystein Thorvaldsen. Courtesy the artist; **162** 8th International Istanbul Biennial, Istanbul, 2003. Courtesy White Cube. © Doris Salcedo

-

For Simon, Mary and Jem

With many thanks to my parents, Ann and Tony Rudd

-

First published in the United Kingdom in 2023 by Thames & Hudson Ltd, 181A High Holborn, London WC1V 7QX

First published in the United States of America in 2023 by Thames & Hudson Inc., 500 Fifth Avenue, New York, New York 10110

Contemporary Art © 2023 Thames & Hudson Ltd, London
Text © 2023 Natalie Rudd
Design by April

British Library Cataloguing-in-Publication Data
A catalogue record for this book is available from the British Library.

Library of Congress Control Number 2022945653

ISBN 978-0-500-29670-7
Printed and bound in Bosnia and Herzegovina by GPS Group

Be the first to know about our new releases, exclusive content and author events by visiting
thamesandhudson.com
thamesandhudsonusa.com
thamesandhudson.com.au

Front cover: Yayoi Kusama, *Infinity Mirrored Room – Gleaming Lights of the Souls*, 2008. Mirror, wooden panel, LED, metal, acrylic panel, 2.87 x 4.15 x 4.15 m (9 ft 5¼ in. x 13 ft 7½ in. x 13 ft 7½ in.). Photo Suhaimi Abdullah/Getty Images. Courtesy of Ota Fine Arts and Victoria Miro. © YAYOI KUSAMA

Title page: KAWS, *HOLIDAY*, 2019. Inflatable, length 37 m (121 ft 4¾ in.). Victoria Harbour, Hong Kong. Photo @harimaolee. © KAWS

Page 4: Doris Salcedo, *Untitled*, 2003 (detail from page 162). 1,550 wooden chairs, 10 x 6.1 x 6.1 m (32 ft 10⅛ in. x 20 ft ¼ in. x 20 ft ¼ in.). 8th International Istanbul Biennial, Istanbul, 2003. Courtesy White Cube. © Doris Salcedo

Chapter openers: page 8 Takashi Murakami, *Flower Ball (3-D), Kindergarten*, 2007 (detail from page 41); **page 22** Annette Messager, *Eux et Nous, Nous et Eux*, 2000 (detail from page 38); **page 46** Urs Fischer, *You*, 2007 (detail from page 65); **page 70** Bruce Nauman, *Dance or Exercise on the Perimeter of a Square (Square Dance)*, 1967–8 (detail from page 73); **page 94** Louise Bourgeois. Museo Guggenheim, Bilbao featuring Louise Bourgeois, *Maman*, 2001 (detail from page 18); **page 118** El Anatsui, *Dusasa II*, 2007 (detail from page 131); **page 140** Ai Weiwei, *Colored Vases*, 2007 (detail from page 155)

Quotations: page 9 Reproduced in https://gagosian.com/exhibitions/2018/murakami-abloh-technicolor-2/ [accessed 10 October 2022]; **page 23** Reproduced in https://www.mariangoodman.com/usr/documents/press/download_url/98/bomb-winter-1989-.pdf [accessed 10 October 2022]; **page 47** Reproduced in https://purple.fr/magazine/317827-autosave-v1/urs-fischer-2/ [accessed 10 October 2022]; **page 71** Reproduced in Jane Livingston and Marcia Tucker, *Bruce Nauman: Works from 1965 to 1972* (Los Angeles County Museum of Art, and Praeger, Los Angeles and New York, 1972), p. 31; **page 95** Reproduced in https://www.tate.org.uk/kids/explore/who-is/who-louise-bourgeois [accessed 10 October 2022]; **page 119** Reproduced in https://www.newyorker.com/magazine/2021/01/18/how-el-anatsui-broke-the-seal-on-contemporary-art [accessed 10 October 2022]; **page 141** Reproduced in https://www.theguardian.com/artanddesign/2016/jan/01/ai-weiwei-sets-up-studio-on-greek-island-of-lesbos-to-highlight-plight-of-refugees [accessed 10 October 2022]